HISTORY & TECHNIQUES OF THE
Great Masters

TURNER

HISTORY & TECHNIQUES OF THE
Great Masters

TURNER

William Hardy

CHARTWELL
BOOKS, INC.

A QUANTUM BOOK

Published by Chartwell Books
A Division of Book Sales Inc.
114 Northfield Avenue
Edison, New Jersey 08837
USA

Copyright © MCMLXXXVIII
Quarto Publishing plc.

This edition printed 2003

ISBN 0-7858-1649-6

QUM9TUR

This book is produced by
Quantum Publishing Ltd.
6 Blundell Street
London N7 9BH

Printed in China by Leefung-Asco Printers Ltd.

CONTENTS

THE PAINTINGS

INTRODUCTION

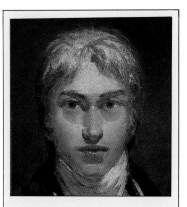

J.M.W. TURNER
Self-portrait
c 1798
Clore Gallery for the Turner
Collection, London

"All lookers on were amused by the figure Turner exhibited in himself, and the process he was pursuing with his picture. A small box of colors, a very few small brushes, and a vial or two, were at his feet, very inconveniently placed; but his short figure, stooping, enabled him to reach what he wanted very readily. Leaning forward and sideways over to the right, the left hand metal button of his blue coat rose inches higher than the right, and his head, buried in his shoulders and held down, presented an aspect curious to all beholders, who whispered their remarks to each other, and quietly laughed to themselves. In one part of the mysterious proceedings Turner, who worked almost entirely with his palette knife, was observed to be rolling and spreading a lump of half transparent stuff over his picture, the size of a finger in length and thickness."

This description of Turner completing a picture — one of his several versions of the *Burning of the Houses of Parliament* — on varnishing day before a Royal Academy exhibition tells us much about the way he worked. It also sums up a popular view of the artist, who appears as a mysterious figure, obsessed by his work and oblivious to events around him, producing as if by magic a picture of the swirling elements from an intense smearing, brushing, scratching, sponging and blotting. The technical mastery that enabled Turner to suggest every subtlety of nature and its effects was barely comprehended by most of his contemporaries. Even today, to eyes accustomed to the freedoms of contemporary art, Turner's late work seems to stand on the extreme limit of oil painting — the work of a revolutionary who broke all the conventions and canons of taste of his day. However, like many other great painters, Turner attained these heights of virtuosity from the most down-to-earth training in the conventions and craft of painting. "D--d hard work" was what he once gave as the secret of his success, and every technical effect that he brought to his work was the result of just this. In the production of the pictures he often referred to as his "children," all else was sacrificed to obsessive, continual work.

Early training in watercolor

Joseph Mallord William Turner came from a humble background, the son of a London barber in Covent Garden. His father quickly saw his son's talent and encouraged him by exhibiting and selling his drawings from his own premises. From this early beginning Turner acquired a keen business sense and an appreciation of the importance of financial success, which he realized was the only way to provide the freedom he needed to develop his work. He came to the notice of a well-to-do amateur painter, Dr Monro, who lived a few streets away and paid a group of young artists (among them Thomas Girtin) to make copies of his collection of watercolors. Through this mundane but valuable process the young Turner learned more or less at firsthand the techniques and style of the leading watercolor painters of the day. Although watercolor was considered a less elevated form of painting than oils, a thriving and highly skilled school of watercolorists had grown up in England by the late eighteenth century. These artists satisfied a strong and increasingly sophisticated public demand for "views" — of landscapes, towns and historical buildings, both at home and abroad. Engravers often worked alongside the painters, popularizing their work in a wider and more lucrative market through widespread reproduction.

Turner quickly mastered the dry descriptive style of topographic drawing and painting, where the principal concern was for accuracy. He became a skilled draftsman, able to produce faithful renderings of architectural detail, but also capable of conveying landscape and weather effects when necessary. These were favorite subjects of watercolorists, as the delicacy and subtlety of the medium is well suited to conveying effects of light and atmosphere, indeed, from the painters' point of view this was the principal virtue of the

medium, and Turner's precursors had become increasingly fascinated by the challenge it presented. Watercolor is also a very demanding medium, requiring both skill and accuracy to control its extreme fluidity and to produce an effect which cannot easily be altered or repainted. Building up on the work of the previous generation, Turner and his contemporaries at Dr Monro's had developed a highly sophisticated technical vocabulary, and were increasingly interested in extending its conventions beyond the tradition of straightforward representation. An extremely subtle range of tones enabled them to depict the full range of atmospheric effects, thus enhancing their work with a sense of mood or even drama that made them more than mere "views."

The growth of the Romantic movement

This maturity in the English watercolor school as it reached toward a more expressive style was part of a universal and profound shift in taste throughout Europe toward the end of the eighteenth century. This is perfectly reflected in the development of Turner's art, which provides the clearest expression in the whole of English painting of this change in attitudes. A concern for order and harmony, qualities which articulated an optimistic view of a world run according to rational laws, was gradually being superseded by a new interest in an art that depicted creation as exciting, dynamic, even hostile. The old classical values — the preoccupation with perfectly poised, objective beauty created by an adherence to set rules of taste — had produced a certain blandness, and in reaction to this connoisseurs began to interest themselves in an art that could be a means of exploring emotions rather than presenting peace and harmony. The taste for the less rational, the more evocative and mysterious, grew throughout the eighteenth century, in reaction to the established reverence for the ordered art of ancient Greece and Rome, and by the end of the century had become almost universal. It was now coherent enough to be given a name — Romanticism.

Nature, as seen through landscape, was crucial to Romanticism, but now Nature was wild and unkempt, not placid and idealized as it had previously been. Turner's choice of landscape subjects was thus typical of the period, and both he and his contemporaries began to explore the mountains, hills and rugged coast of Britain. When a temporary peace was signed in the war against France he crossed the Channel to add the greater splendor of the Alps to his repertoire. The quality most admired in such scenes was the "Sublime," which was seen as the stimulus to an exciting and spontaneous

sense of awe, awaking in the observer a thrilling sense of his own weakness in the face of the giant irrational power of nature. The concept of the Sublime was most fully developed by the English statesman and philosopher Edmund Burke (1729-97), who suggested that "darkness, vacuity and silence" were the qualities that attended it — qualities readily to be found in Turner's views of mountain scenery.

The sea fascinated Romantic artists in the same way as wild mountains did. Its vast scale dwarfed men and their ships, who were helpless before the power of the elements when traveling over it. It suggested the infinite, and by association, death, the great oblivion that held a particular fascination for the Romantics. Turner's first exhibited oil painting, *Fishermen at Sea off the Needles*, of 1796, showed a small boat on a rough sea at night, the moonlight increasing the drama of the scene, an image which introduced a series of works depicting storms and the perils of the sea.

Themes in painting

Turner's art combines the themes and motifs of Romantic painting and literature with more personal

S.W. PAROTT
Turner on Varnishing Day
c 1846
University of Reading, Ruskin Collection

Turner greatly enjoyed the sociability of the varnishing day before a Royal Academy exhibition. He sometimes

transformed a roughly prepared canvas into a finished work in the space of a few hours, and he became a source of some amusement to his fellow artists, most of whom were content to simply apply the statutory coat of varnish to their paintings.

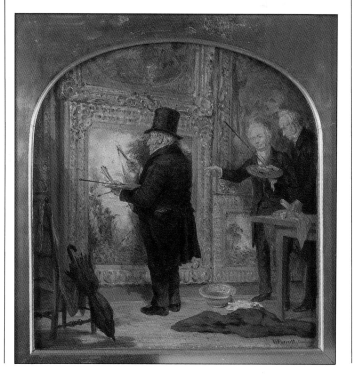

and often obscure concerns. This is not as paradoxical as it might appear, for Romanticism celebrated the individual view against the impersonal orthodoxy of the established, and its heroes were those who, because of the intensity of their private vision, were misunderstood or even rejected by the majority. Suffering and loneliness were seen to enhance the integrity of the artist. Turner's character and life can be seen within this context, since although he was convivial in the company of his fellow-artists and those with whom he felt at ease, he was not equipped for the kind of elegant society life that would have brought him fashionable recognition. Small, and with a strikingly large nose, shyness gave a gruffness to his manner that emphasized the curtness of many of his responses to uninformed enquiries. He was always extremely sensitive to criticism, and his strong desire to

be understood was combined with a conflicting urge toward obscurity. His ineptness for expressing himself in words contrasted poignantly with his eloquence in paint. Thus John Ruskin, his most sensitive and perceptive champion, recounted how, "The want of appreciation touched him sorely, chiefly the not understanding his meaning. He tried hard one day, for a quarter of an hour, to make me guess what he was doing in the picture of 'Napoleon,' before it had been exhibited, giving me hint after hint, in rough way; but I could not guess and he would not tell me."

Turner was indeed obsessively private, to the point of developing elaborate veils of secrecy around certain aspects of his life, hiding his mistress and even his address from his contemporaries. To his neighbors in Chelsea in the 1840s he was known as a retired admiral, having taken for local convenience the surname of his mistress and landlady, Mrs Booth. This state of mind could only have been encouraged by the almost universally hostile criticism his work attracted from his early maturity onward. Even when such comments were clearly ignorant and expressed in the most vulgar idiom of the day they wounded Turner deeply. His paintings were said to be "soapsuds and whitewash," "cream or

J.M.W. TURNER
Transept of Ewenny Priory
1797
National Museum of Wales,
Cardiff

The romanticism of this medieval subject is given extra drama by the depth of shadow

Turner could bring to his watercolors. A contemporary critic compared this interior, with its gloomy grandeur and dappled light, to the work of Rembrandt, whom Turner came to admire later in his career.

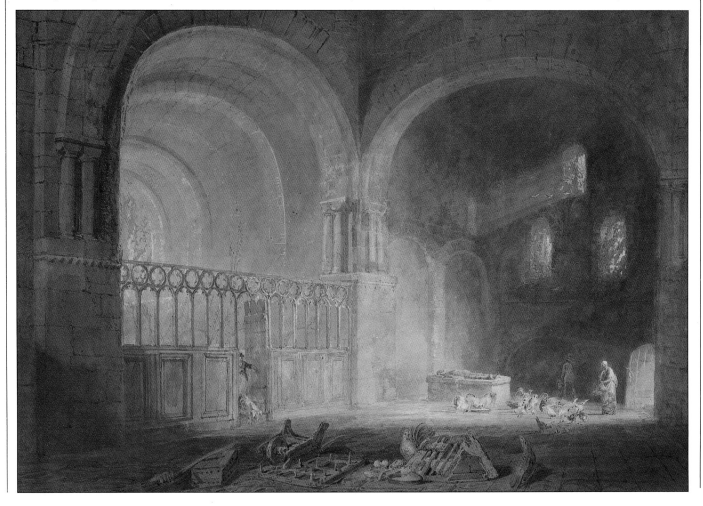

chocolate, or yolk of egg, or currant jelly," "eggs and spinach," "mustard," "produced as if by throwing handfuls of white and blue and red at the canvas, letting what chanced to stick, stick." The casual attribution of "mad" to his later style must have caused particular distress, since his mother had died in the Bethlem Hospital for the Insane. The epithet continued to be used after his death by French critics, applied to the passion and fury of his later works.

The isolation of the artist, and by extension, of man himself, was a recurring theme in Romantic art. Turner frequently used the plight of a great hero as the central theme of a picture, a hero frequently rejected, punished or set apart from his fellows by some remarkable and distinguishing powers. Examples are the lonely Napoleon in exile; the disgraced and blinded Regulus; Moses writing the book of Genesis (after the Flood, in Turner's confused biblical chronology); or Masaniello, the doomed leader of the Neapolitan rebellion. As the artist matured, his themes became more dramatically concerned with the futility of man's efforts, which could be eroded by the tide of history, as was the great empire of ancient Carthage, which sank into decadence, decline and eventual destruction. Carthage was the theme of several of his works. Man's efforts were similarly threatened by the savage elements, which could wreck simple fishing boats as easily as they could terrify the hardened troops of the Carthaginian general Hannibal as they crossed the Alps into Italy. Man could struggle against avalanches, storms and floods just as he struggled against the power of fate, but eventual defeat was inevitable. The theme of death — sometimes elegiac, as in *The Fighting Téméraire*, where the aged battleship is towed away, and sometimes violent and bloody, as in *Slavers Throwing Overboard the Dead and Dying*, where slaves are cast out to be devoured in the savage sea — increasingly dominated Turner's work, accompanied by a deep pessimism.

The role of literature

However, it is not only the lonely profundity of his work that connects him with the other isolated spirits of Romanticism. Apart from the common images of Romantic painting — Gothic ruins, lonely heroes, storms and gloomy skies — he was familiar with the work of the contemporary poets. Although he had no formal education, and his thoughts as they appear both in his writing and reported speech often appear unstructured and confusing, many contemporaries remarked upon the essential keenness of his mind. He eagerly assimilated any knowledge that was of practical benefit to him, for

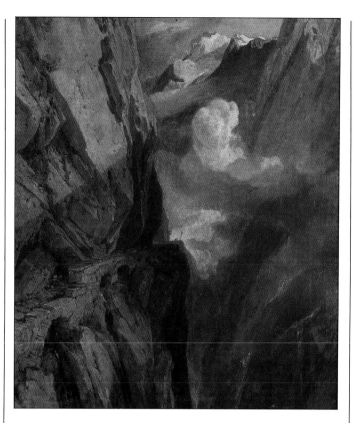

J.M.W. TURNER
The Passage of the St Gotthard
1804
Birmingham City Museums
and Art Gallery

Turner first went abroad in
1802, going first to the Alps

and returning via Paris and
the Louvre. He painted several
watercolors of the dramatic
Alpine scenery, one of which,
exhibited in his own gallery in
1804, formed the basis for this
oil painting.

instance teaching himself the rudiments of French before his first trip abroad, and the importance of his reading is evident in his art. This is well illustrated in the close relationship between poetry and English landscape painting that had grown up during the eighteenth century. At this time poets had acted as a major stimulus to landscape painters through pastoral descriptions, themselves inspired by the Old Master Italian landscapes collected by the English aristocracy. James Thompson's *The Seasons*, for example, with its lengthy evocations of weather and landscape, enjoyed an enormous vogue, and the success of this work gave Thompson's selection of natural scenes an increased prestige as subjects for works of art in their own right. Thus Turner used lines from *The Seasons* to accompany many of his paintings, particularly his early oils, which he may possibly have felt needed some support to elevate them into fully fledged pictures rather than "views."

Progressing from Thompson, Turner began to exhibit his paintings with lines from a poem of his own, *The Fallacies of Hope*, an incomplete work whose title served to link together the various fragments he produced to rein-

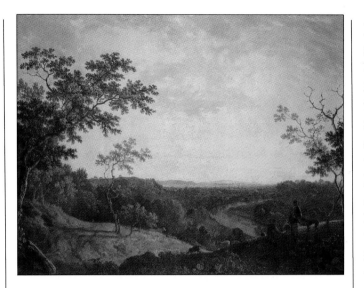

RICHARD WILSON
The River Dee
c 1762
National Gallery, London

Wilson began as a portrait painter, but his real interest was landscape, and it is for these that he is remembered. Like Turner, he was much influenced by Claude, and Turner saw him as his only major predecessor in the kind of art which successfully combined a sensitive rendering of the English landscape with the grandeur and drama of the Italian classical tradition.

force particular paintings. It may seem surprising to us in the present day that he felt the need for such addenda when his work can be appreciated for its purely visual qualities, but this was entirely in keeping with his ambition: deeply imbued with a respect for art in its traditional spiritual role, he wished his painting to be placed in the context of feelings and ideas and not just visual sensations. The *Aeneid*, the masterpiece of the Roman poet Virgil, was also among Turner's reading matter, particularly valued for its story of the Carthaginian queen Dido and its natural descriptions. He was equally familiar with the works of his contemporaries, Byron and Shelley, perhaps the most widely read of the English Romantic poets at the time, and several works were inspired by passages from Byron. This literary awareness brought him closer to the heart of the Romantic movement, which at the time was as much literary as visual.

Turner and the art establishment
Although this picture of Turner, the lonely, pessimistic artist painting landscapes of passionate turmoil, fits easily into an historical context of the Romantic movement, it is a portrait that the artist himself might not have recognized. Despite his innovations in technique, the visionary nature of his work and the mockery of some critics, Turner was in many ways a fervent upholder of tradition and the artistic establishment. His instinctive respect for the institutions of his profession

had its origins in his humble beginnings, and it was of great importance to him to become an associate of the Royal Academy at the age of twenty-four (in 1799) and a full member three years later, not only financially, but in terms of security and recognition. His social awkwardness made him doubly appreciative of the company and support of his fellow painters, and he remained loyal to the Academy throughout his career. As a student he had learned life drawing in the Academy Schools, and had attended the last lecture of the great founder, Sir Joshua Reynolds (he may even have attended Reynolds' studio in the company of other young painters eager for informal instruction). Turner never failed to refer to Reynolds with great respect, partly for his painting style and technique and partly out of natural reverence for his professional achievement. When Turner was appointed professor of perspective at the Academy he took his obligatory course of lectures with great seriousness, no doubt aware of the weight of tradition supplied by the founder's famous discourses on art.

Turner's highly developed sense of history was, typically, the product of conflicting feelings: the insecurity caused by his humble background and a sense of his own value that enabled him to regard the great masters of the past as his equals and rivals. These feelings spurred on his well-developed professional ambition, and continually throughout his career he produced works that were in direct response to the success of a contemporary — works that enabled him to learn, assimilate and compete. His relationship with the Old Masters worked in very much the same way, and he produced what amounted to updated interpretations that were simultaneously homages and challenges.

Major influences
Turner's influences were catholic, but were fundamentally derived from the seventeenth century, the first heroic age of landscape painting. The two schools of this time were those of the Dutch and Italian. The Dutch had painted their landscape for its own sake, without the inclusion of any "storyline" other than the day-to-day activities of its inhabitants, and the interest of their work lies in the vivid depiction of nature and the changing effects of climate. These paintings were unpretentious works painted for a middle-class public, and were popular among English artists and collectors who found the straightforward depiction of landscape, as well as the landscape itself, compatible with their own outlook. By Turner's day the Dutch influence on British painting was well established, and is the primary source of the topo-

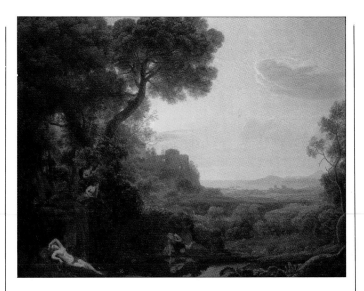

CLAUDE LORRAINE
The Embarkation of the Queen of Sheba
1648
National Gallery, London

On seeing this for the first time in his early twenties, Turner said, "I shall never be able to paint anything like this picture." Now, in accordance with his will, his own tribute to Claude, *Dido Building Carthage* (see page 27), hangs next to it in the National Gallery. Claude painted many variations of the theme of a classical seaport, all of them featuring a rising or setting sun and its reflection.

graphical work with which he began his career. Of more direct importance to him were the Dutch seascape painters, to whom he was naturally drawn in his continual re-examination of his favorite subject. Again it was in a spirit of both homage and competition that Turner echoed in his own paintings the work of the Dutchman Van der Velde (see page 19).

A different tradition of landscape painting had arisen in seventeenth-century Italy, led by the Frenchman Claude Lorraine. He was inspired by the warm, even and unchanging light of the countryside around Rome, and used it in his carefully arranged and idealized landscapes. These, unlike the simple Dutch landscapes, had a "storyline," and although the landscape was the real subject, figures relating to a biblical, mythological or classical tale were always placed unobtrusively in the foreground. With these works Claude created the style of historic landscape that became much admired and was considered by the academies of Europe as more prestigious than the mere view painting of the Dutch. Claude's undisputed eminence in landscape had a powerful fascination for Turner, who was mesmerized in particular by the luminosity of the paintings, the way in which the subtle glows of morning, afternoon and evening were conveyed through the glazes of oil. After studying Claude's work in the collections of his patrons, Turner's first trip to Italy in 1819 took on the nature of a pilgrimage to the source of this ideal world.

Turner also studied the work of Claude's contemporary and compatriot Nicolas Poussin, whose paintings were a less lushly lit and more austerely controlled variant on the classical landscape. The clarity of Poussin's work, usually based on posed studio studies of models, seems distant from Turner's more dynamic approach taken from direct outdoor experience, yet the two shared a concern with theme, or content, in their landscapes. Turner's respect for the traditional view of how the business of art was to deal with the most elevated themes — very much the viewpoint of the academician — accords with his concern to give the maximum intensity to his own landscapes. His early admiration for Richard Wilson, his major precursor in English landscape painting, can also be seen in this context. Wilson had also traveled to Italy to see for himself the light that had inspired Claude, and his panoramic, balanced compositions and golden light effects were an important early influence on Turner, who described such works as being "replete with the aerial qualities of distance, aerial lights, aerial color." Wilson, who had begun as a portrait painter, had attempted to win the same level of prestige for landscape. In this he had only limited success, but his classical landscapes in the Claudian manner succeeded in transposing onto the familiar British scenery something of the grandeur and drama of the biblical or mythological scenes for which he used it as a setting. Thus he served as an important example to Turner just as the latter was breaking out from the particular of the watercolor genre to the broader stage of oils.

NICOLAS POUSSIN
The Deluge
c 1640
Louvre, Paris

Turner greatly admired the somber coloring of this work when he studied it in the Louvre on his first trip abroad. At this time his own coloring was still quite subdued. He was also drawn to the treatment of natural disasters, which became a strong theme in his work.

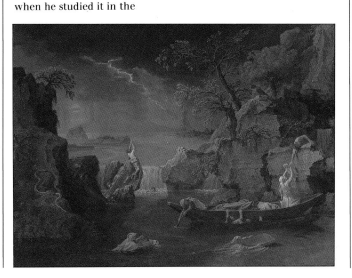

Recording and observation

But while Turner looked to Romantic literature and the Old Masters to give greater force to his work, the essential foundation for his painting always remained his concentrated observation and recording of nature itself. His visual memory was such that he could store the details of a particular weather effect to reproduce it exactly in a work produced years later, but despite this ability he relied also on painting directly from nature. On each trip he made, either at home or abroad, he filled sketchbooks with watercolors and drawings done on the spot, as had become usual for a topographic artist. At a later stage he classified the sketches by subject or theme and stored them until needed, so that he had a huge reference file of fresh impressions to be consulted when working on large canvases.

This was the normal working method of the oil painters of the day, who would use such sketches as the raw material for a work conceived and painted in the studio, but as so often in matters of technique, Turner took the practice one step further, producing small oil sketches as well as watercolors in the open air. He started this around 1806-7, just slightly before his contemporary Constable began the same practice. Both painters were using oils in a new way, to record impressions rapidly and accurately at firsthand, and this free and personal response to nature was to make a great impact on French painters (more stifled by academic tradition than the English) when they developed first the Realist movement and then the Impressionist movement later in the century. Turner subsequently returned to watercolors as his customary medium for recording color impressions, but his early oil sketches, painted from a boat in the Thames, remain an important step in establishing his own personality as a painter. His first biographer records how, later in life, he was fond of taking a bottle of gin with him on such occasions, a habit that discouraged the two boatmen who rowed him along the river from believing that their passenger had indeed been a great painter.

Turner's close observation of nature gave rise to an interest in natural science, and his obsession with light made him particularly interested in exploring the closely related problems of light and color as perceived by the human eye. He was familiar with Newton's earlier use of the prism and discovery of the spectrum, and he

J.M.W. TURNER
Snow Storm: Hannibal and his Army Crossing the Alps
1812
Clore Gallery for the Turner Collection, London

Here Turner evokes the imminent defeat of the great hero through the drama of the storm, said to have been based on one he had observed in Yorkshire two years earlier. The painting marks the beginning of his interest in the Carthaginian empire, while the way the paint is applied looks forward to the style which Turner himself termed "indistinct" and Constable described as "tinted steam."

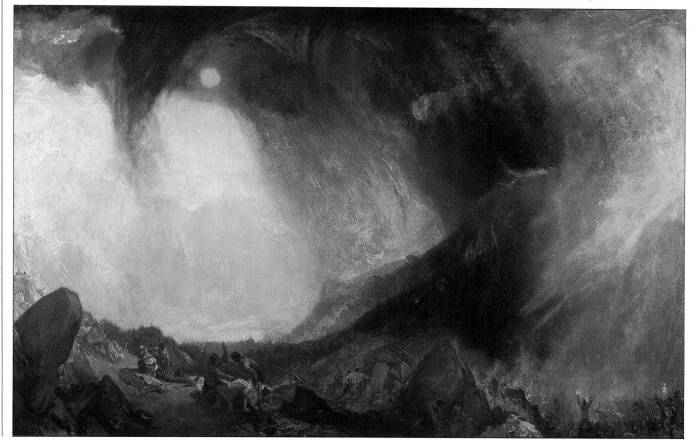

TURNER'S PAINTING METHODS

In this detail from The Dogana, San Giorgio *we see Turner's use of impasto to emphasize the clouds in the pale sky.*

In Norham Castle, Sunrise *the thin paint applied over the brilliant white ground gives a luminous effect similar to watercolor.*

For details such as this, from Peace: Burial at Sea, *Turner used thin paint applied with a fine, pointed brush.*

Turner's oil-painting technique is dazzling, particularly in his later works. He was a true craftsman as well as a great artist, and was constantly pushing forward the frontiers of experience in his search for the means to convey drama, emotions and the effects of nature. As his career progressed, he began to use increasingly vivid and pure colors, preferring to work on a light ground that reflected back through the layers of paint to give a glowing luminosity to his work. From the start he adopted broad under-painting, but instead of the traditional mono-chrome brown or ocher he used pale washes of color, such as pinks, blues and yellows, which both established the composition and enhanced the effect of the colors added sub-sequently. These were laid over one another on the canvas rather than being premixed on the palette. He used a great number of dif-ferent techniques, such as knife-painting, scumbling, thick impasto and thin glazes, often combining all of them in one painting to give a marvelously varied paint surface.

His watercolor technique is no less revo-lutionary — in an age when the standard method was to apply a series of thin, pale washes over a careful pencil or pen drawing, Turner mixed his paint with gouache, gum arabic or pencil to give it more body, and then created highlights by removing areas of paint with blotting paper or a damp brush. Some-times, when working rapidly on the spot, he would allow the colors to mix into one another or drip down the paper, exploiting each effect as it occurred to create magical evocations of light and atmosphere.

Before the mid-nineteenth century, when ready mixed paints in metal tubes were introduced, paints were sold in powdered pigment form and stored in glass bottles prior to grinding and mixing with oil. The prepared paint was kept in small bladders — visible at the back of the box. Oil painting outdoors was a much more laborious process than it is today, but Turner, who was deeply committed to working from nature, was one of the first to use oil paint as an outdoor sketching medium. In general, however, he preferred watercolor or pencil, filling sketchbook after sketchbook with visual "notes" that were later used as reference for finished compositions.

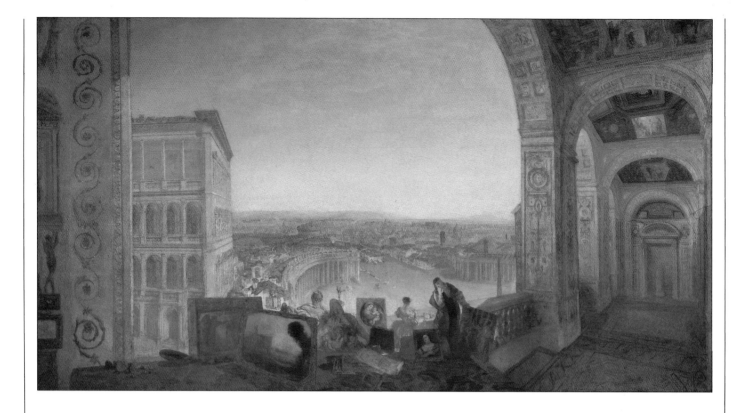

J.M.W. TURNER
Rome from the Vatican
1820
Clore Gallery for the Turner
Collection, London

This was Turner's first oil to
be directly inspired by his visit
to Italy. An ambitious and
slightly awkward composition,
it shows Rome as though
viewed by Raphael, who is
shown in the foreground
surrounded by his works. The
art-historical theme
emphasizes Turner's self-
consciousness in approaching
Italianate subject matter.

followed the contemporary studies on the same theme, reading the English translation of Goethe's book on color theory with close attention, and experimenting with some of its ideas in his work.

The Turner who was a painstaking and clearheaded observer of the world around him may seem to contrast with the Turner who was the creator of such highly personal and visionary works, but in his greatest work the two strands intertwine. In these we are presented with scenes that are immediately convincing as visual experiences, but are also filled with great drama and personal feeling. His genius amplifies the private drama of his characters or of his own emotions into a drama of nature itself, and the apparent opposites are united into a vision of the world which is both personal and universal. Indeed, much of the excitement of Turner's work is created by the attempt to combine disparate elements, with the tension between the revolutionary and the academician, the observer of nature and the inspired visionary, giving enormous vitality to an art that deals so eloquently with movement, conflict, change and the passing of time.

Turner's legacy

Turner died in 1851 at the age of seventy-six, and his estate included 350 oil paintings and 20,000 drawings and watercolors. These were only his unsold works, but when added to the considerable number sold throughout his career they give a good idea of the nature and scale of his lifetime of unceasing activity. Within this vast *oeuvre* there is tremendous variety, but also a strong thematic continuity, a quality Turner himself was well aware of. He tended to think of his work as a unity, a natural extension of the many series that it contained, and some works he refused to sell, while others were bought back by him from their first owners so that they might return to their place in the whole. This concern for completeness, an interesting complement to the theme of destruction and loss that appear in many of the paintings, extended to the terms of his will, in which he left all the works in his possession to the nation on the condition that they be displayed together. This condition understandably created grave problems, and has only recently been fulfilled with the establishment of the modern Turner gallery alongside the Tate Gallery in London. In this gallery, whose ancestor was the one the painter himself had added to his London house, it is possible to see the private, experimental and preparatory works alongside the more polished pieces to which they contributed, a unique collection which echoes and reinforces the artist's high estimation of his own work implicit in the terms of the bequest.

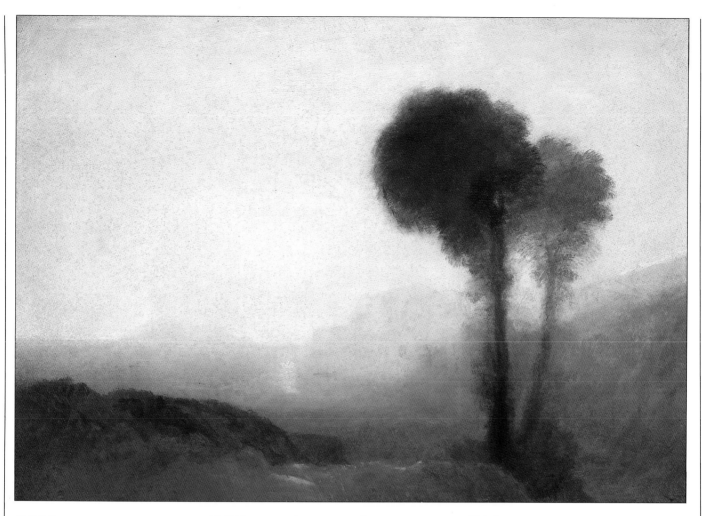

J.M.W. TURNER
Coast Scene near Naples
1828?
Clore Gallery for the Turner
Collection, London

This is one of Turner's
sketches, or "color
beginnings," in which he tried
to capture the exact hues of
the sunlit landscape,
regardless of detail. It is one of
a group of ten such works, on
board, probably done on his
second visit to Italy. These
truly Impressionist pieces,
which would later be used as
reference for a finished
painting, show him
concentrating on light and
color as the essence of his
work.

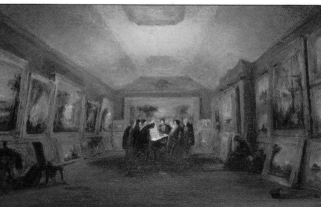

GEORGE JONES
*Turner Lying in State in his
Gallery*
1852
Ashmolean Museum, Oxford

Turner had built his own
gallery, an extension of his
house, when he began to
become successful, reserving
it for his more private or
experimental paintings. When
he died he was laid out in the
gallery, surrounded by the
pictures he found it so
difficult to part with. One of
these, visible here, is *Dido
Building Carthage*, which he
had once expressed a wish to
be buried with.

CHRONOLOGY OF TURNER'S LIFE

1775	April 23: born in Covent Garden, London.
1789	Admitted to Academy Schools.
1794-97	Works for Dr Monro copying his collection of drawings and watercolors.
1796	First oil painting exhibited at Royal Academy, *Fishermen at Sea off the Needles*.
1797	First tour of the north of England.
1799	Made associate of the Royal Academy. Receives commission for topographical watercolors.
1800	Mother admitted to Bethlem Hospital for the Insane.
1802	Elected full member of the Royal Academy. Earl of Egremont starts buying his work.
1804	Builds his own gallery as extension to house.
1805	Paints *The Shipwreck*. Mother dies.
1807	Made professor of perspective at Royal Academy Schools. First volume of *Liber Studorium* issued.
1810	Paints *The Fall of an Avalanche in the Grisons*.
1812	Paints *Hannibal Crossing the Alps*.

The Shipwreck

Norham Castle

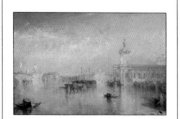

The Dogana, San Giorgio

1815	Paints *Dido Building Carthage*.
1817	Visits the Netherlands and Rhine valley.
1819-20	First visit to Italy; sees Rome, Venice and Naples.
1828	Travels to Rome via Paris.
1829	Paints *Ulysses Deriding Polyphemus*. Father dies.
1830	Paints *The Evening Star*. Begins to stay regularly with Earl of Egremont at Petworth.
1833	Second visit to Venice.
1834	Paints several versions of *Burning of the Houses of Parliament*. Exhibits illustrations to Byron's poetry.
1837	Death of Earl of Egremont. Probable date of *Interior at Petworth*.
1839	Takes cottage in Chelsea as retreat.
1840	Meets John Ruskin. Third visit to Venice.
1842	Paints *Peace, Burial at Sea* and *The Dogana, San Giorgio*.
1844	Paints *Rain, Steam and Speed*.
1850	Exhibits for last time.
1851	19th December: dies in Chelsea.

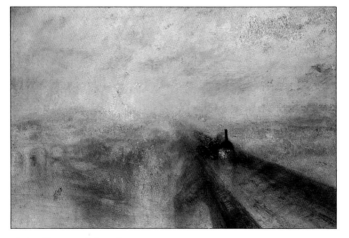

Rain, Steam and Speed

THE PAINTINGS

THE SHIPWRECK

1805

67½×95in/171.5×241cm

Oil on canvas

Clore Gallery for the Turner Collection, London

Turner explained that "this made me a painter" when examining a print of a Van der Velde seascape with a friend. *The Shipwreck* is one of a series of paintings beginning with his first exhibited oil and continuing through the National Gallery *Calais Pier*, in which Turner expands and develops the Dutch genre of seascape. The Duke of Bridgewater, who owned a Van der Velde seascape, had stimulated this sequence by commissioning Turner to produce a matching work to hang with it. Growing up close to the banks of the Thames where the merchant and naval ships were moored, Turner had a detailed personal knowledge of the subject.

Here he extends the usually modest dimensions of the genre to the more monumental scale of a full-blown academic work, and an earlier theme begins to become more explicit. In his previous seascape treatments there had been a heavy swell, or rough sea, but this now becomes a life-threatening tempest, with endangered and clearly mortal man engaged in a struggle against the elements. The theme which emerges in this painting was one that was to reappear again and again in Turner's work. The wrecked ship itself is placed in the background, almost obscured by the sail of the largest boat; the foreground drama is that of the struggle of the survivors in their tiny craft. The composition perfectly evokes the turbulence of the water, a formless, ever-changing mass which allows Turner greater freedom than could the more defined and substantial features of land. An ellipse provides the focus of the picture, suggesting continual swirling movement and the depths into which the survivors are in danger of being drawn. From this point on Turner's imagination was to return continually to the form of the ellipse or vortex, which he used to represent the superhuman forces with which he became increasingly fascinated. Not only did the stormy sea give him a freer hand with composition, but his brushstrokes also became less inhibited when conveying the movement of water, and the oil paint itself, applied with enough vigor to suggest it had been splashed across the canvas, provided an equivalent to the spray from the waves. It was this kind of paint handling that first attracted the charge of a "lack of finish," but Turner's desire for more vivid realism surpassed that of Van der Velde (see opposite), whose technique was more polished, with a much more generalized treatment of the water's surface.

The Shipwreck was exhibited, not at the Royal Academy, but at Turner's own gallery which he had completed as an extension to his house in the spring of 1804, the previous year. This was a substantial room, seventy feet long, which demonstrates how successful Turner had already become in financial terms. He opened the gallery at a time when the future of the Academy seemed uncertain: it was bitterly divided between rival factions, either supporting or opposing King George III's attempts to encourage a more significant production of royal, "official," art. The turmoil had already encouraged the formation of two independent groups, the Society of Watercolour Artists and the British Institution. The creation by an artist of his own gallery was unusual for the time, but it was typical of Turner's concern for security and independence. He continued to use his gallery throughout his life, for the display of more private works, passing its management to his old father when he built another house for himself outside London, on the river at Twickenham.

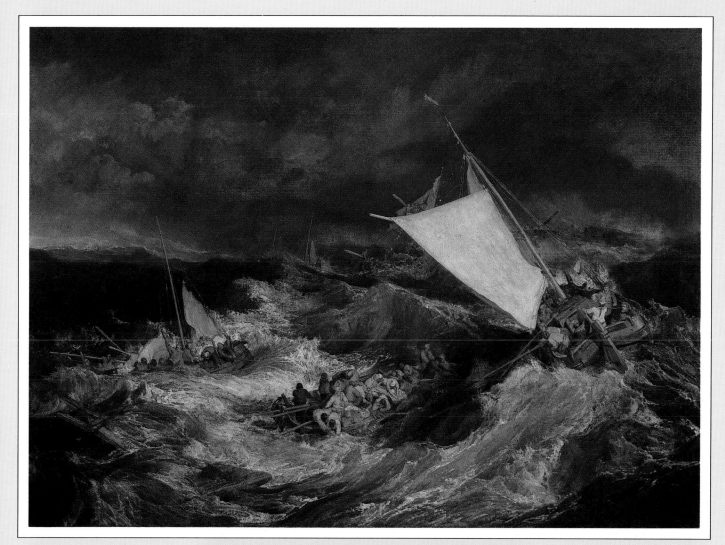

Turner's brushwork parallels the fluidity and movement of the sea in its direction and application. The looseness of handling seen in the details seems to anticipate his late style. But this is deceptive, for here speed and spontaneity of execution are combined with great care in building up the surface by means of many different hues and small, patient brushstrokes. The preference for a dark ground, from which the highlights are worked up, is also typical of his early work. This is a large painting, and from a distance the looseness of touch in some areas draws the eye in to the fine detail in others. Through the contrast in paint handling, Turner has given extra drama to the subject, his brushwork emphasizing the force of the water directed against the tiny, helpless figures.

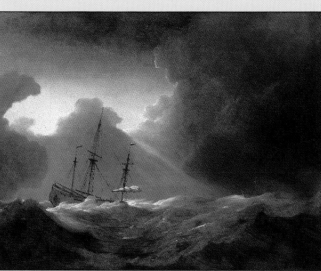

WILLEM VAN DER VELDE
1633-1707
Ship in a Storm
National Maritime Museum, Greenwich

Early in his career Turner was commissioned to paint a seascape to match a work by Van der Velde, a task which he was pleased to carry out, attempting to surpass the Dutch artist's realism. The Dutch seascape painters were of great importance to him, and he is supposed to have said, when looking at a print of such a painting, that "this made me an artist."

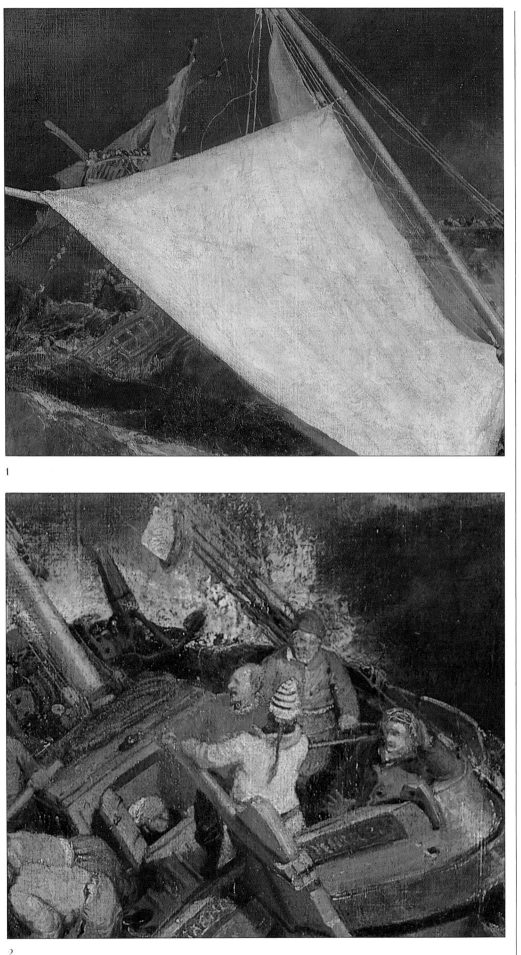

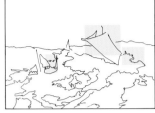

1 The sail is the area of the thickest and most opaque paint. The path of the brush through the pigment is clearly visible, with faint lines of underpainting showing through the marks of the hairs. Behind the sail lies a shattered fragment of the prow of the wrecked boat, whose details are sketched in with single strokes of umber.

2 Here the flexibility and originality of Turner's technique have been reined in. Paint is applied in thick dabs, and barely moved across the surface except in the pink used to describe the surface of the rudder. A series of discrete flat areas are juxtaposed in sharp, clear-cut contrasts, particularly in the red, white and black of the sailor's clothes.

3 *Actual size detail* Over the deep gray underpainting visible beyond the foam Turner draws strokes of pale gray-green leading to a vortex of foam just above the side of the boat. This is applied in dilute paint, so that its surface is relatively smooth, like a semi-transparent veil of water thrown into the air. Touches of white and a bluer green are mixed in in places, and over this, brief individual touches of white and blue-green suggest flecks of foam and spray. These are applied thickly toward the border with the boat, and thin and dry as they fade away over the background at the crest of the wave.

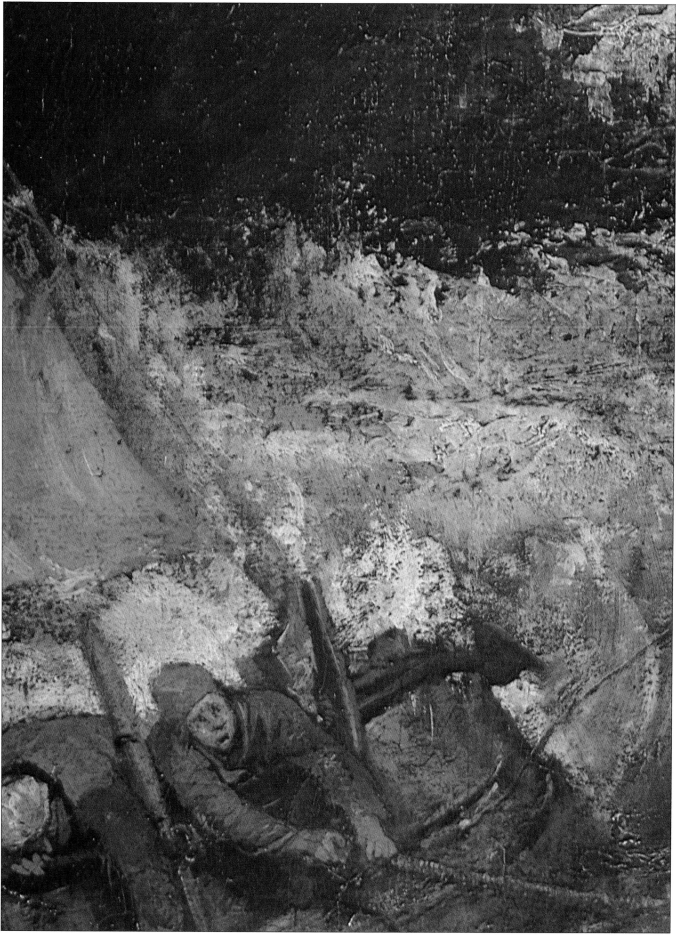

3 *Actual size detail*

THE FALL OF AN AVALANCHE IN THE GRISONS

1810

$35\frac{1}{2} \times 47\frac{1}{4}$ in/90.25×120 cm

Oil on canvas

Clore Gallery for the Turner Collection, London

Turner had visited Switzerland eight years before this work was painted, and on the same trip had studied the Old Masters in the Louvre, Paris. Despite the somewhat muted enthusiasm implied by his comment that "the Country on the whole surpasses Wales, and Scotland too," the Alps clearly made a deep impression on him. They represented the apogee of the Sublime, and he drew and painted them with that quality in mind, emphasizing the deep ravines, huge cliffs and dangerous paths. By the time of this work Turner's interests had progressed beyond simply capturing the Romantic grandeur of the conventionally picturesque, and had become more ambitious and personal. The setting here is Switzerland, but it is a part which he had not visited, and neither had he witnessed an Alpine avalanche, although he had seen several dramatic thunderstorms which are clearly remembered in this work. Avalanches had, however, been painted by his contemporary Philip De Loutherbourg, from whom he had earlier learned to depict dramatic night effects. This type of synthesis, combining minutely recalled natural detail with a more open visual reminiscence of a fellow artist, is typical of Turner's way of thinking.

The fact that he was moving beyond the detached depiction of a natural phenomenon is stressed by the nine lines of verse he included with the work when it was exhibited. These close with the following:

And towering glaciers fall, the work of ages
Crashing through all! extinction follows,
And the toil, the work of man — o'erwhelms.

These are Turner's own lines, but they appear to be partly inspired by a passage describing an avalanche in the *Winter* poem of Thompson's *The Seasons.* In the painting, the agent of the destruction of the work of man is the massive boulder poised to crush the tiny foreground cottage. This powerful image expresses clearly and concisely the complete destruction of man's works, although no human being is in sight. The composition is pared down to a clash of conflicting diagonals, differentiated by tone and by the variety of surface treatment Turner gives to snow, rock and cloud. In both handling and composition it is an unusual work for this stage in Turner's career, and was shown in his own gallery as too unconventional for an academic context. It anticipates *Hannibal Crossing the Alps* (see page 12) which was to be painted two years later, where natural disaster echoes the destruction of the Napoleonic wars which at that time were threatening the canton of Grisons.

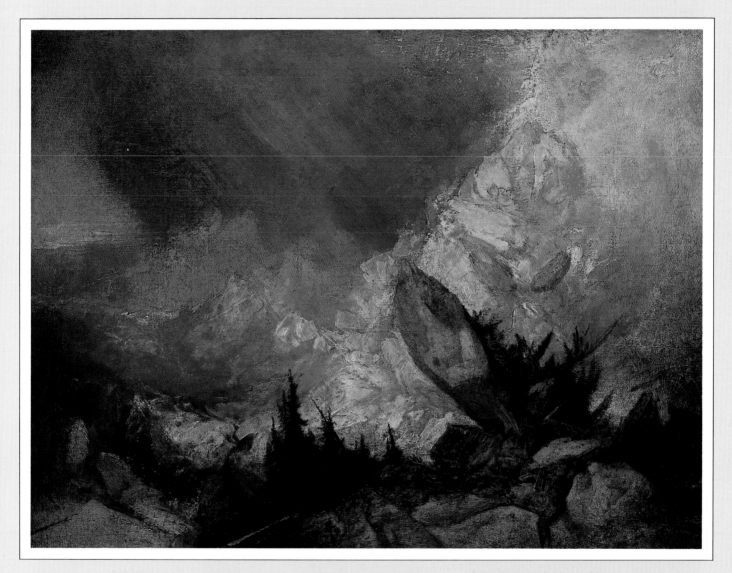

Typically for one of Turner's early oils, color is almost ignored here, except for the dull browns of the foreground rocks, and the whole composition is an exercise in the use of tonal relationships. A narrow range is used effectively to set off the brilliance of the snow, dramatically emphasized by the dark rock. The disregard for detail, however, is an unusual feature at this stage in Turner's career, and the broad areas of underpainting have an almost abstract impact. Such roughly painted areas occur in all Turner's paintings, but here they have been left more clearly visible to become imprecise suggestions of storm, sky and snow. The way the avalanche has been painted is also unusual; its boldness anticipates the late work, but lacks the variety of handling that Turner was later to develop.

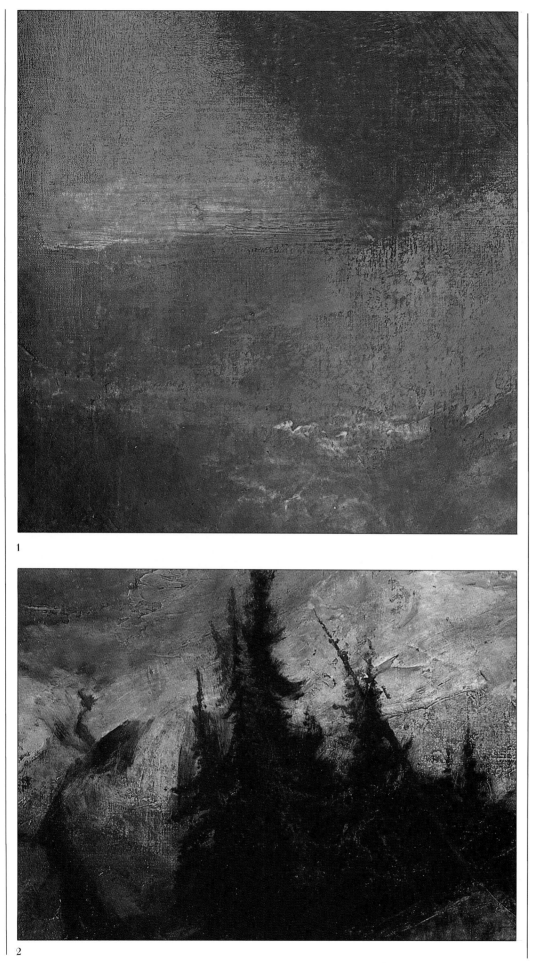

1

2

1 Turner's use of "long,"or heavily diluted oil paint can be seen clearly here. The underpainting is dark gray, seen in the extreme left where the bare canvas begins. Slashes of white cross it and are covered by a mid-tone gray, thinly applied and dragged down so that the canvas weave can be seen above the area of highlight. Toward the touches of white indicating the crest of the avalanche, more paint is applied, but still very fluid, so that tones blur together. The diagonal dark stormclouds are applied with long strokes, drier toward the margins.

2 The paler underpainting of the trees has been applied while the background was still moist, but the finer details of trunks and branches demanded a drier brush. To the left of the trees the direction of the brushstrokes follows the movement of the snow, with two rapid strokes producing a gash of dark gray. A very thin blue-gray, recalling a watercolor wash, has been drawn over the more solidly applied white.

3 *Actual size detail* The paint has been applied most loosely at the point where the avalanche buckles up on striking the ground, for here Turner was free from the demands of depicting solid forms. Slabs of thicker white are used near the cottage, and elsewhere they are applied flatly with the palette knife. Leaving patches of bare canvas between, the more fluid blue-gray has been vigorously brushed on, mixing with the white beneath. The reverse technique has been used on the boulder, where thick buff highlight areas are applied over a thin, dark umber ground.

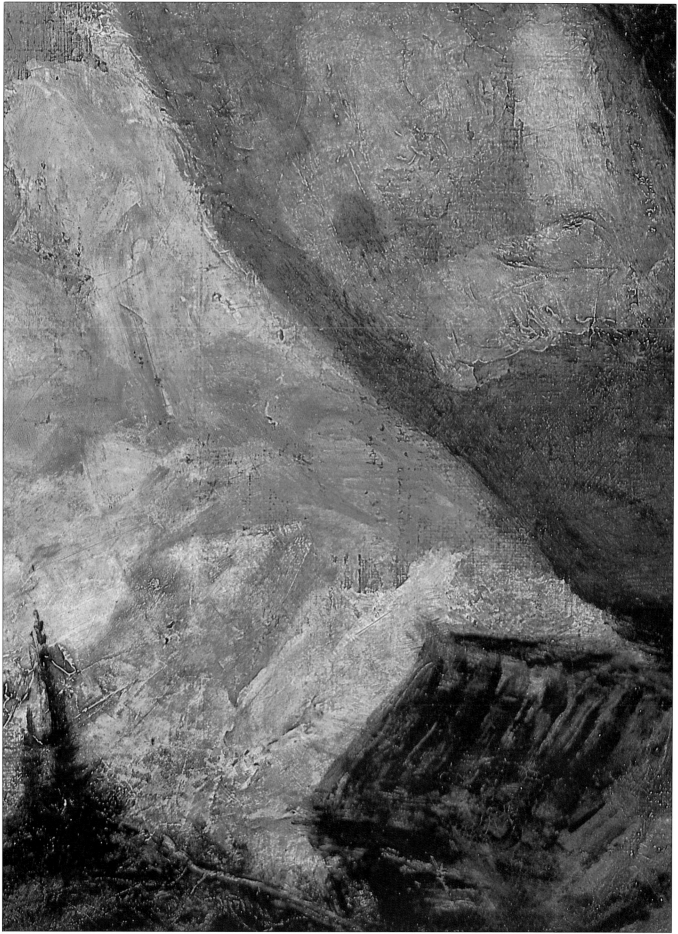

3 *Actual size detail*

DIDO BUILDING CARTHAGE

1815
61¼×91¼in/155.5×231.75cm
Oil on canvas
National Gallery, London

Turner was deeply attached to this work, which he considered one of his finest. Like many of his favorite pieces, he retained it in his studio, but in conditions of such complete neglect that on his death it was rediscovered covered with grime and with paint peeling off, an example of the complex mixture of obsessive attachment and casual indifference with which he treated finished paintings. In his will he left the work to the nation on the condition that it was hung between two Claude landscapes, where it still is today (one of these, *The Embarkation of the Queen of Sheba*, is illustrated on page 11).

Dido Building Carthage is one of the best examples of the several works painted during Turner's thirties, in which, now a mature artist, he measures himself against Claude. In doing this he also provided a rebuttal to the increasingly dismissive conservative critics who continually compared his work unfavorably with that of Claude and his contemporaries. Turner scored his most popular successes with these Italianate works, painted before he had actually visited Italy.

According to a contemporary, Turner's reaction to the first Claude he saw in a private collection in 1799 was that "he was both pleased and unhappy while he viewed it, it seemed to be beyond the power of imitation." Sixteen years later Turner could match his master, but in doing so he was also able to emphasize his own concerns. As a painter of light he echoed Claude, and here he produces typically Claudian effects: a direct view of the sun, light reflected on water, and an accurate evocation of the transitory light of a particular time, here sunrise. The classical seaport setting is also typical of Claude, although the inventiveness and detail of the architecture also reminds us of Turner's earlier skill as a topographical artist and his term as professor of perspective at the Academy. The large tree set against the light, and the buildings used as framing elements to either side are similarly derived, but they are not used with the kind of theater-scenery rigidity typical of Claude. Instead of the Claudian technique of bands of diminishing tones laid across the landscape to create recession, one sees here a more complex and evocative pattern of shadows and highlights which is completely of its time. The mood thus created is more unsettled, giving drama to the subject.

It became an increasing habit of Turner's to conceive works in pairs, and in 1817, two years later, he painted a matching work, *The Decline of the Carthaginian Empire*, a sunset scene. Rise and decline, shown in sunrise and sunset, are the recurring cycles of man's fortunes. Queen Dido's Carthage, a subject taken from Virgil's *Aeneid*, was a trading and naval power that Turner associated in his own mind with the rising fortunes of Britain. His depiction of the boys in the foreground, who watch their toy boat sail into the reflection of the morning sun, symbolizes the hope of the young nation, while the thoughtful gaze of the woman behind them hints at a note of foreboding realized in the works to come.

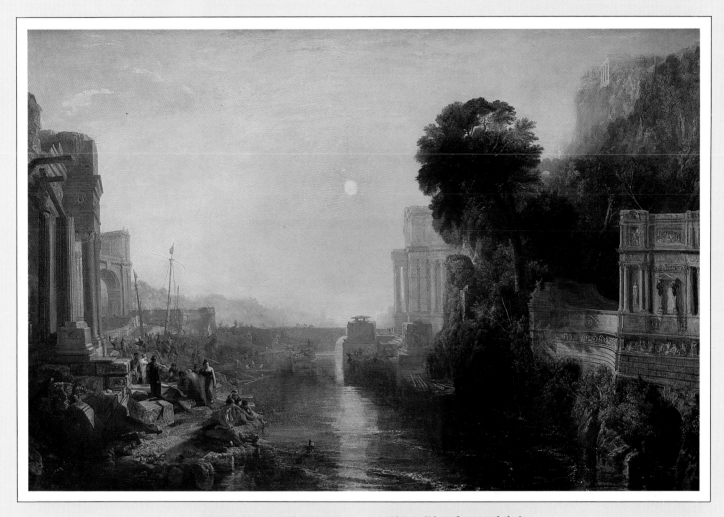

This work is one of the most "finished" in Turner's whole career. A great amount of attention has been put into each part of the surface, and many areas have been meticulously worked, although what appears at first sight to be conventional detail is achieved by the most summary of strokes. Turner's use of paint is less fluid than is usual in his later works, and the surface is in general drier, denser and more homogeneous. The attention paid to solid surfaces and their textures is also greater than in subsequent works, where air and water predominate. Color is muted, subordinated to overall tonality and unified by the use of glazes in the traditional manner; indeed Turner has striven to accommodate all the conventions of the traditional style without compromising his own. After his visit to Italy the balance tipped toward brighter color and looser handling.

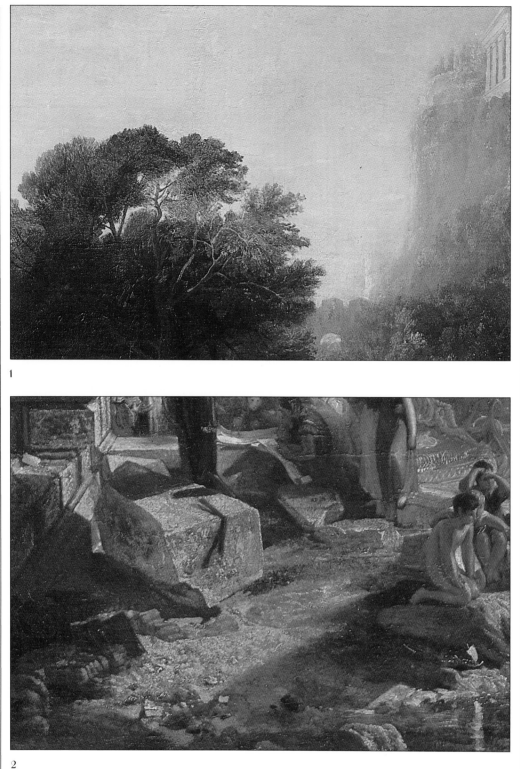

1

2

1 The dark tree set against the pale sky is the main device for creating depth. The tree is built up from a pale underpainting, visible on the peripheral leaves. The subtle sense of distance is achieved through transparent, finely tinted glazes, yellow laid over the pale blue sky and clouds, and pale green over the touches of white in the cliffs.

2 The surface of the cut marble to the left is suggested by rough dots of chalky white applied with little dilution. Dense dabs of pale blue and yellow have then been added and allowed to half dry before having longer, freer strokes of blue-gray smeared over and around them, creating a smoother finish. The surface has been built up with great care to suggest the rough-hewn texture. The coldness of the marble block and the nearby rocks provides a counterbalance to the warm reds in the group of boys.

3 Turner uses the Claudian near monotone to suggest distance, here the same pale blue-green that Claude had used in his seaport scenes. The masonry covering of the bridge is picked out in a cooler blue, with one zigzag stroke used to create the vertical column of the reflection beneath the arch. The receding shoreline shows Turner's masterly control of tone, with an extremely pale rose tint laid over pale gold to suggest land, and a pale blue used to sketch in a distant boat.

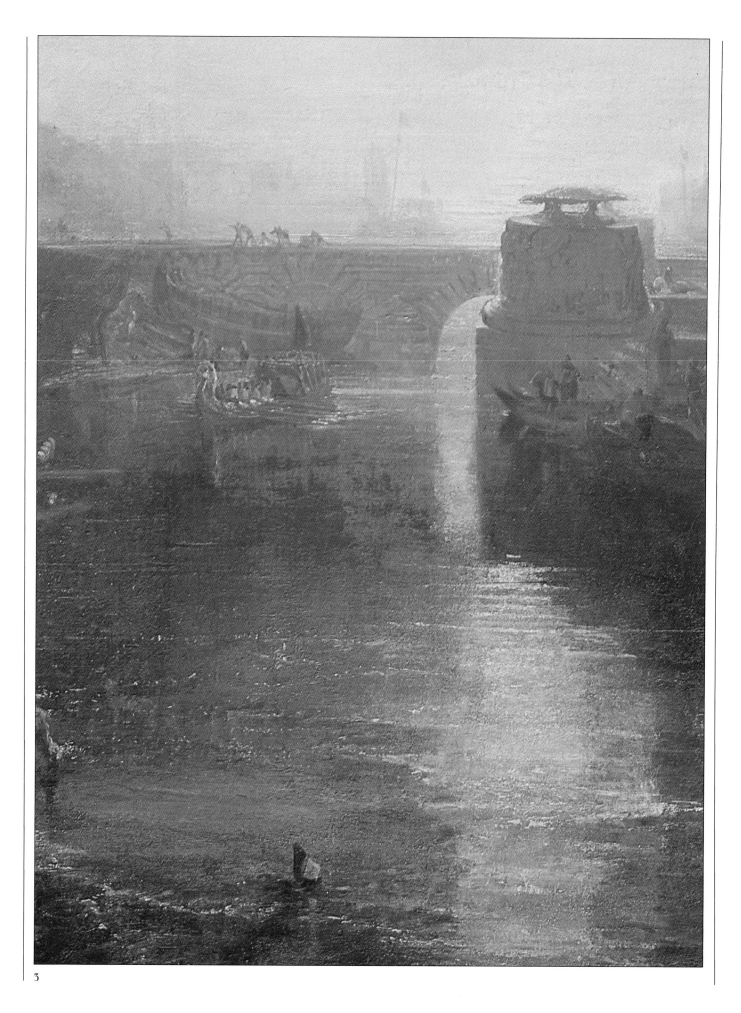

3

ULYSSES DERIDING POLYPHEMUS

1829
52¼×80in/132.75×203cm
Oil on canvas
National Gallery, London

The critic and art historian John Ruskin saw this as "the central picture of Turner's career," and it marks the beginning of the last two decades of Turner's life when his work became increasingly assured and self-contained. The influence of his trips to Italy now emerges as the chief spur to his increasing originality. His private response to Italy had been expressed in watercolors that were concerned with the discovery of the new possibilities presented by the light and color, but for some time after his first visit in 1819 his preoccupations in oil-painting were as much with the traditional Claudian and classical view of the country as with his more vivid personal impressions. *Rome from the Vatican* (see page 14) showed him to be still in the earliest stages of absorbing what he had seen, and feeling inhibited by the depth of art history that lay before the modern traveler. It was not for some years after his first visit that he fully digested the experience.

Turner produced a sketch of *Ulysses Deriding Polyphemus* (see opposite) when in Italy on his second visit in 1828, and the painting itself was done the following year. The influence of Italy is more apparent in the painting technique than in the classical subject matter or in the setting, though the latter is perhaps reminiscent of the southern Italian coastline he had seen on his first tour. On his second trip to Italy, he experienced not only the vivid hues of the sunlit landscape, but also the pure colors of the Gothic and early Renaissance paintings that were becoming fashionable among young English and German painters working in Rome. He began to use purer colors, and he grew less and less reliant on the use of colorless tones to build up his picture. Finally, colors darkened by black disappeared altogether in favor of pure hues. This contrasted dramatically with the conventional academic technique, which aimed at an overall harmony of tone and hue at a much lower pitch, helped by the use of dulling glazes. This was in part a misconceived ideal based upon revered works of the past, many of which were only dark because they had grown so with age, but connoisseurs had become accustomed to this effect, and therefore valued subtle tones in a very narrow range, with little disturbance from strong color. Turner now rejected these values as positively as he also turned his back upon the academic requirement of "finish," a concept that included fine detail and a very smooth application of paint.

The change that was heralded by this work did not go unnoticed by his contemporaries. The critic of the *Morning Herald* noted that it marked "a violent departure from his old style" with "coloring run mad — positive vermilion, postive indigo, and all the most glaring tints of green, yellow and purple." The brightness of these colors conjures up the glowing heroics of myth and the pagan violence of the epic. The blinded giant Polyphemus is left alone on the island, his seated form seeming to blend into the landscape, masked in cloud suggestive of a volcano. Beneath him, the sea glows in the light of the sunrise — an effect partly inspired by the artist's reading of contemporary accounts of phosphorescence in tropical waters.

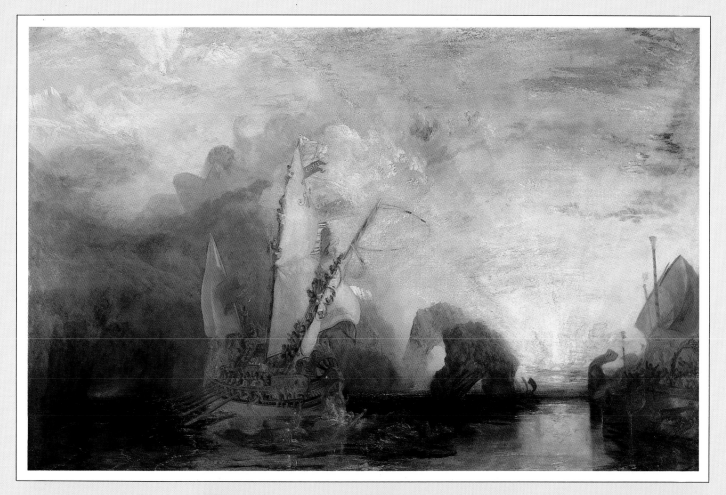

The color and brushwork here clearly show the artist in his maturity, moving confidently away from the traditions of the Old Masters toward the originality and modernity that were to lead to his critical isolation. Yet echoes of Claude, forever associated in Turner's mind with classical themes, remain strong. Cliffs, rocks and ships are all arranged around the sunrise in a manner reminiscent of the seaport scenes by Claude that he had studied so closely. The use of strong silhouettes set against the light, as in the ship's prow and the distant sail, are also traditional devices, and ones that Turner was to use less as his art developed.

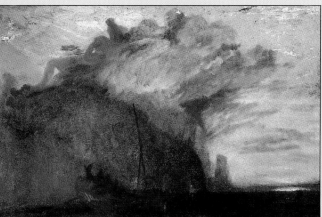

This is the first experimental oil-sketch made on the theme, painted while Turner was in Italy, a year before the painting itself was completed. Such sketches were executed rapidly and freely, using much-thinned paint, but all the main elements of the later composition are included, with the addition of a more clearly defined volcano behind the figure of the giant.

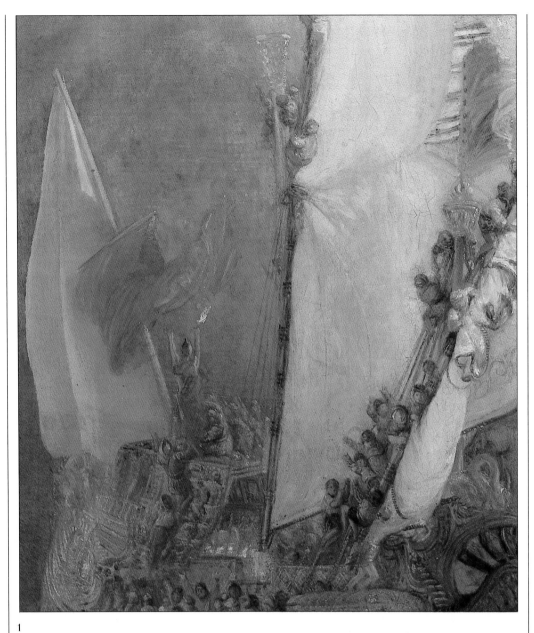

1

2

1 The area behind the ship is extremely smooth, so that the ship is pushed forward, and the division between the sails and the background is kept sharp. On the main sail, a pale application of blue is used to cool the shadow and echo the tones of the background cliffs. A few dabs of paint describe Ulysses, holding up a torch and highlighted by a fluttering scarlet above, a counterbalance to the blue-striped sail.

2 The sea-nymphs who accompany Ulysses' ship are painted in a gray-green monotone with tiny touches of white impasto for the star-like lights on their foreheads. Elsewhere, similar touches are used as the points of light on the water's surface, thus linking the nymphs with their medium.

3 *Actual size detail* The brightest, purest colors in the picture are also the areas of the thickest paint. The paler blue underpainting is built up by dark, dry horizontal strokes of deep blue that create the horizon, with below, a comparatively thin layer of pale yellow overlaid with even more transparent touches of pink forming the background of the sea. Over this, thickly applied white is partly scraped away to produce the reflected highlights of the sunrise. The sun itself is more thick white painted around an opaque bar of yellow, pulled into crimson at the right, while scratched white impasto and faintly opaque glazes form the diagonal rays of light.

3 *Actual size detail*

THE EVENING STAR

1830

36¼ × 48¼ in / 92 × 122.5 cm

Oil on canvas

National Gallery, London

While working on his more ambitiously dramatic works Turner continued to paint the familiar and intimate English scenes that he knew so well. Certain themes and favorite landscapes he returned to at regular and sometimes protracted intervals throughout his life. He was particularly attached to the River Thames, beside which he lived, and he painted views of the river from the Berkshire valley to the estuary. *The Evening Star* can be traced back to a number of views of fishing in the Thames estuary, of around 1808, where the foreground clutter of fishermen and nets has been removed to create empty, airy compositions with only distant sails breaking the even line of the horizon. In *Calais Sands, Low Water, Poissards Collecting Bait,* he returned to the theme of a long bare expanse of beach, a bare canvas on which he could concentrate on atmospheric effects. This was painted in the same year as *The Evening Star,* and probably depicts the same scene, which he had revisited on a recent trip to northern France. A contemporary comment on the former work could apply equally to both: "it is literally nothing in labor, but extraordinary in art."

The Evening Star might well have been painted to balance the more full-blooded effects of *Ulysses Deriding Polyphemus* (see page 31), but although in a quieter, more somber key, it is just as much a pure-color painting from which colorless shading has been removed. The fanfare of the *Ulysses* is here replaced by an elegiac tone in which carefully controlled touches of red and gold are subtly harmonized into the prevailing purples and silvers. Turner's use of a subtly gradated tonality and a severely limited palette shows a painter in his maturity, creating his effects with the maximum of precision and economy. No brushstrokes are squandered in rhetorical embellishment, but the widest variations of textures of sky, sea and sand are suggested with the fewest possible strokes. The musical analogies of which Turner was fond seem especially apt for this work, where the solitary barking of the dog on the silent beach provides an auditory equivalent to the growing brilliance of the star setting in the dusk.

The note of elegy, although unforced, is deliberate and perhaps appropriate. Turner was keenly aware of young talent around him, and had been an admirer of the work of Richard Parkes Bonington, who had made his name painting the wide, empty beaches of northern France with a delicate attention to the nuances of atmosphere. Bonington had died prematurely — at the age of twenty-six — two years earlier, and it is natural that Turner should have thought of him while absorbed in a similar subject. Even without this specific reference a soft mood of acceptance and peace accompanies the end of day, and calls to mind a more intimate sense of loss, that of Turner's beloved father who had died the year before and whom he mourned deeply.

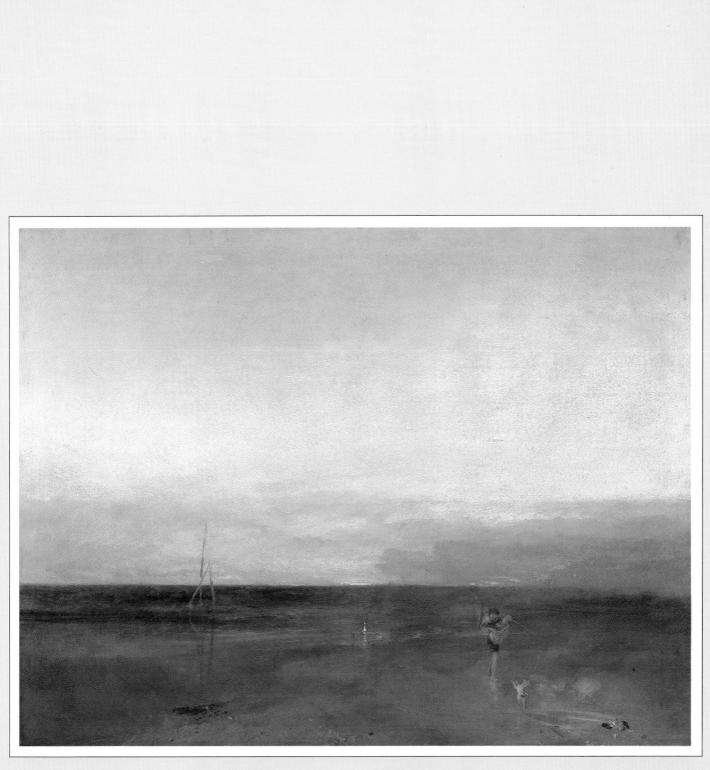

As an unfinished work, this gives us an insight into Turner's method of building up a painting. In particular, the lack of narrative incident concentrates the attention on the fundamentals of land, sea and sky. Great care has been taken with the translucence of the various layers of underpainting, best seen in the painting of the beach, where the relationship between the underlying warm brown and the blue-gray over it is particularly sensitively controlled. The changing opacity of both is carefully varied either by the amount of oil mixed with each pigment or by rubbing down after application.

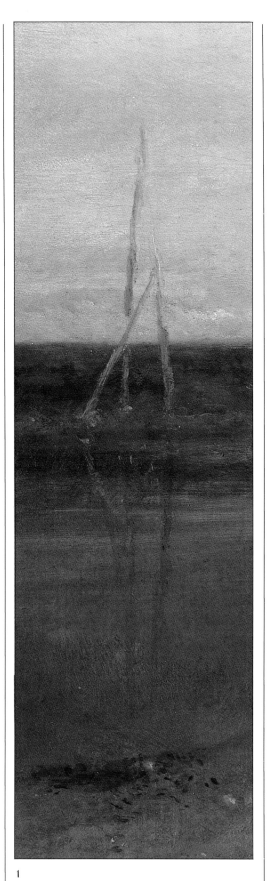

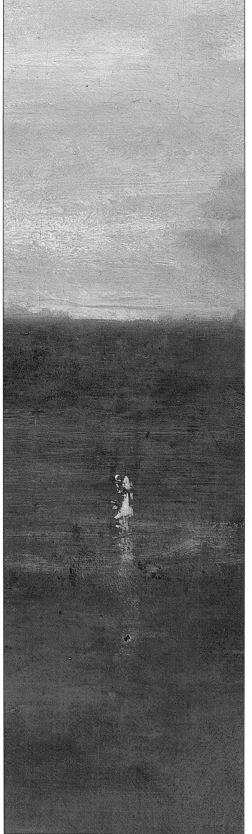

1

2

1 The tall spar set against the sky is drawn in several quick downward strokes, identifiable by the way the color fades as each stroke continues down. The surface of the distant water appears at first glance to be smooth, but in fact it owes its subtlety of color to densely applied small strokes of paler blue over the deep color beneath. A few horizontal bands of dark crimson are drawn across to separate the spars from their reflection in the shallow waters, which are single faint continuous strokes extending until the brush is cleared of paint.

2 A moist and quite thick gash of white is used above the horizon to emphasize the focal central area, with one scratch across it to give a further horizontal emphasis. The highlight of the reflected star is a single application of white, dabbed on with a few sharp jabs, then pulled down dry to mix with the touches of pale gray suggestive of pale reflections in shallow pools.

3 *Actual size detail* Thick touches of carmine across the horizon suggest the course of the sunset beneath the gathering clouds. A fine, dry brush has been used in continuous strokes for the outline of the boy's net and, more heavily loaded, for the highlights around the rim of his basket. To the right of the dog, some simple, rapid smears of a lightly loaded brush, applied with a sharp turn of the wrist, balance the pale glow of the vanishing sunset.

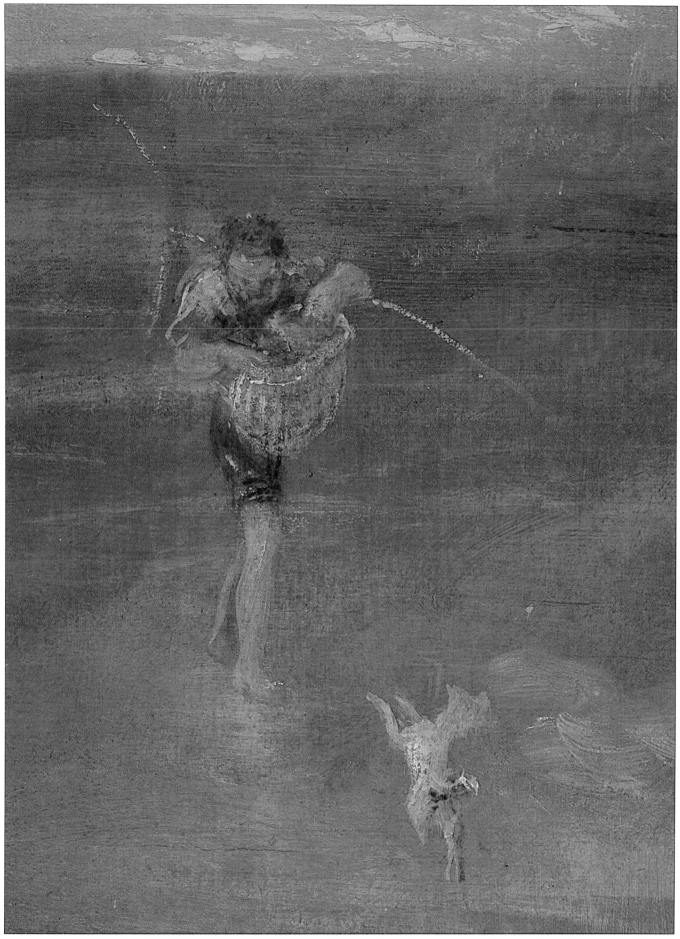

3 *Actual size detail*

INTERIOR AT PETWORTH

c1830-7
35¾×48in/90.75×122cm
Oil on canvas
Clore Gallery for the Turner Collection, London

Turner's most important patron in 1830 was the Earl of Egremont. He had been buying Turner's work since 1802, having commissioned a view of Petworth house, his country seat, and four landscapes specifically for one of the rooms there. Rather than continuing to buy Old Masters, the Earl had decided that his wealth was better spent patronizing living artists, and a large gallery had been built at Petworth to house his extensive collection. The Earl's forthright honesty, complete lack of concern for social convention, and easy-going hospitality made him the center of a large and motley household — reputedly consisting of mistresses and children as well as artists — over which he presided with aristocratic tolerance. From 1830 onwards, when Egremont was already an old man, Turner began to stay regularly at Petworth, and eventually a special room was set aside for him as a studio. Here, in the friendly and informal atmosphere, he felt at ease, and was allowed to work as he pleased. His watercolors of the bright Petworth interiors are among the most spontaneous and charming that he ever produced, capturing in bright colors on blue paper the atmosphere of rooms full of sunlight.

While working on these informal paintings, Turner also had an opportunity to look closely at the other works in Lord Egremont's collection. In a rare figure painting he did at this time he made a number of visual references to Van Dyck, the court painter to Charles I, some of whose aristocratic portraits hung at Petworth. He studied Rembrandt too. As an enthusiast of the sleeker Italianate style he had in his youth been slightly disparaging of the more homely Rembrandt, but as his interest in the manipulation of paint grew, so too did his appreciation of the great master. He noted the way Rembrandt applied paint with a palette knife and used the handle of his brush to scratch into the paint surface in places, and in the landscapes, Turner particularly admired the "streams of light floating over the surface of the middle ground" — a description that could equally be applied to his own work.

Something of the atmosphere of Rembrandt's warm and rather mysterious interiors with their glowing pools of light is recalled here. The subject of the painting is unclear, for it is not of any recognizable room at Petworth; it appears as a kind of composite of the many watercolors Turner had produced there, probably painted after the death of Lord Egremont in 1837. If this is so it can be seen as a tribute and a valediction to the great patron and to a way of life that had gone forever. It has been suggested that the form on the right is a coffin on whose side a coat of arms is discernible, surrounded by a jumble of objects and animals littering the silent room. The picture is a complex synthesis of things thought and things felt. One senses a semi-conscious symbolism in the light flooding into the room from an unseen source, but elsewhere, in the flecks of light dancing in the air or in the reflected glow on soft material, there is a strong sense of Turner painting rapidly and instinctively. The value of this instinctive approach in an artist who often seemed to back away from a full intellectual understanding gives a work such as this the full force of an art still warm and elusive, its impreciseness offering something fully felt and only half understood.

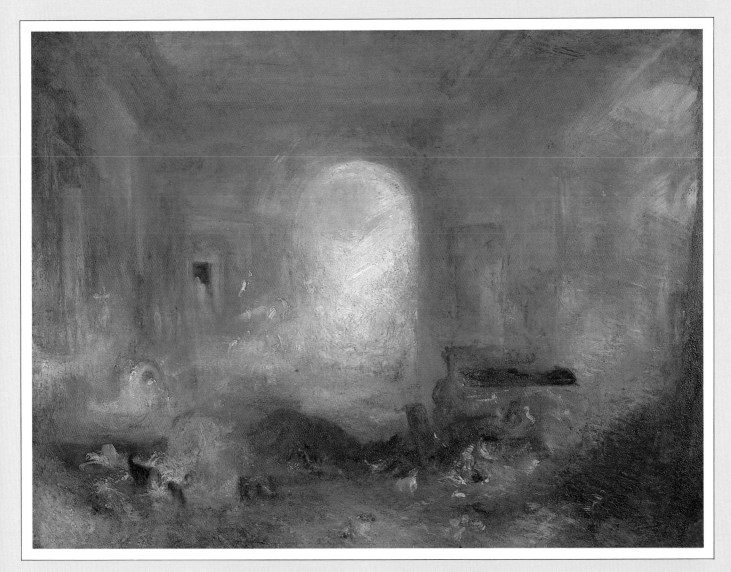

In conventional terms, this is an unfinished work, the sense of urgency and spontaneity in its execution helping to explain the different degrees of attention Turner has accorded to the various parts of the surface. Large areas of the upper canvas are covered with thin and roughly applied color, contributing to the feeling of lightness and space. In the foreground, the greater depth of handling results in a richer use of color as warm hues are mixed to produce a dull glow. Here the plain description of objects has been rejected in favor of a more suggestive evocation of atmosphere. Light and color are the two elements which unite the composition, and the central burst of light, clearly of deep significance for Turner, is echoed around the canvas by subsidiary highlights which help to illuminate the shadowy interior.

1

2

1 A pale tan ground has been overlaid by a deeper umber, itself overlaid by pale gray and white that toward the right have been wiped to create the impression of diffused light from the central arch. Rough strokes of white have been set over the smoothed layers, applied with a rapid twist of the wrist. In most cases the main thickness of paint has been scraped away using the handle of the brush to lessen the impasto and thus create a more insubstantial effect. This technique is carried through into the central area, where the thick paint has been scored and gouged with a sharp tool.

2 Here a form resembling a cornucopia provides the focus for a cluster of light and color, and paint has been applied more thickly and dryly than in the upper areas of the work, helping to give stability to the painting. A deep brick red provides a warm ground to a thick and vivid orange, sponged and blotted to evoke the texture of a rich fabric.

3 Turner has used single strokes of white with great simplicity to suggest reflective metallic objects clustered together in disarray. Here a variety of spontaneous strokes can be seen — dabs, smears and quick, sharp angular touches — all providing an area of highlighted detail to balance that on the left. Only the form of a small dog is recognizable by the touches of white on its chest, brought down to form the legs.

3

BURNING OF THE HOUSES OF PARLIAMENT

1834

$11^{3}/_{4} \times 17^{3}/_{4}$ in/29.8×45cm

Watercolor

Clore Gallery for the Turner Collection, London

The liberation of color that Turner had begun to achieve with *Ulysses Deriding Polyphemus* (see page 31) was further stimulated by the events of the night of October 16, 1834, when he joined the large crowds that had gathered at Westminster, on the banks of the Thames, to watch a fire destroy the Houses of Parliament. This disaster offered Turner a range of glowing colors which could only have been provided in nature by the most vivid of tropical sunsets. The pinks, scarlets and yellows of the flames and the glowing timbers and ashes had the additional attraction for an artist of being set against the contrasting cool deep blues of the night sky and the river in which they were reflected. Turner's excitement at the spectacle is conveyed through the drawings and watercolors he produced as he watched, bustling around on the opposite bank to get a range of different viewpoints. The speed with which he was forced to work to capture the scene before the flames either subsided or were extinguished by the soldiers called in to fight the fire is evidenced by the growing impetuosity that was now apparent in his sketches and the increased freedom of his oil painting. The energy with which he worked when possessed by his subject can be seen clearly — with no time for carefully controlled washes, he let his colors run into one another, exploiting the effect to suggest pale reflections on darker water or a diminishing glow against the night sky. Colors are deliberately left to drip down the paper, then either smudged across the surface with an almost dry brush, or blotted and rubbed. Watercolor thus proved to be the perfect medium with which to capture fire, air and water.

Turner's fascination with fire, which matched his appetite for natural disaster, had been evident from as early as 1792. In that year he had painted the aftermath of a fire on London's Oxford Street, and during his first tour of Italy he had traveled down to Naples to see an eruption of Vesuvius, perhaps the only comparable spectacle to the Parliament fire. Surprisingly, the sight never appeared as a subject of a major oil painting, whereas the nine watercolors he painted at the scene of this fire resulted in two important pictures and three variations — dealing with fires at sea, at a Thames wharf and at Lausanne, all settings which combined fire and water. His enthusiasm for the theme underlines its importance for him at this stage in his development, when an interest in highly pitched color, loose handling and the destructive power of the elements were all becoming more intense.

Typically for Turner, the excitement the subject offered in terms of technique was matched by his interest in the wider implications of the event. The Houses of Parliament embodied the ancient traditions of parliamentary government, and their destruction had an enormous symbolic impact. The 1830s saw growing political and social unrest associated with demands for further political reform. Turner had been a supporter of the earlier Reform Bill which had swept away many of the archaic electoral traditions, and was associated with the more radical elements of the Royal Academy. At a time of further unrest the destruction of the ancient seat of government seemed a distaster of almost biblical proportions, and Turner could not fail to respond to the poetic significance of an event which echoed his own growing fascination with violent destruction.

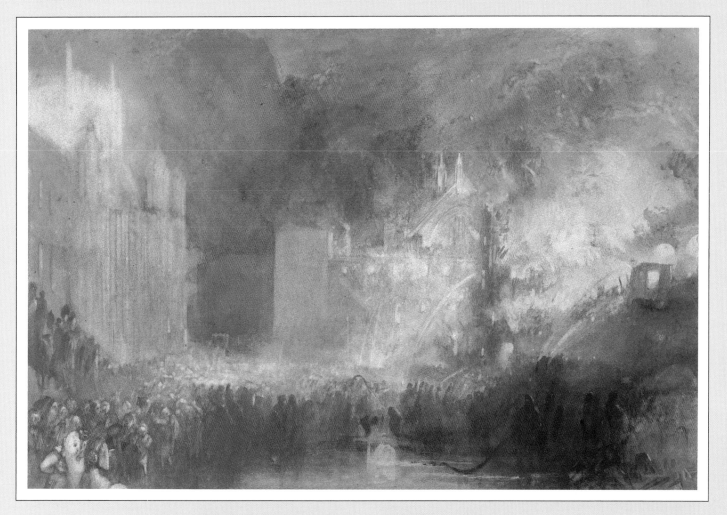

Here Turner has seized on the way the fire reverses the normal tonality of daylight so that solid buildings appear pale and insubstantial. The west end of Westminster Abbey, for instance, is a ghostly form to the left, but in contrast, the night sky, dark and dense with smoke, appears as an almost tangible entity. Although swiftly produced, the composition is nevertheless perfectly coherent. Two large, light areas form the silhouette of Westminster Hall, while the foreground is drawn up in a semicircle leading into the picture and grouped around a pool of blue water reflecting the hue of the sky above.

1

2

1 The crowd on the left is treated in a uniform red monotone, reflecting the glow of the flames. Toward the foreground a few highlights form features, but otherwise the spectators are depicted by quick vertical strokes of a saturated brush, added over a paler wash.

2 The highlights of the flames are created by allowing the pale paper to show through. Individual brushstrokes can be seen clearly along the silhouette of the disintegrating building, while below a flatter surface is formed by a more diluted wash applied with longer strokes.

3 *Actual size detail* In the foreground, paint is applied with little dilution and with a loaded brush to create the effect of the pool of water, laid over vertical red strokes which appear through it as reflections of the bystanders. A touch of blue above has been heavily diluted on the paper to suggest the steam and smoke, and through this Turner has scraped the course of the water jets from the hoses. A flurry of short, hurried strokes draw together the blue of he sky and the flames, blurring the outline of the burning building.

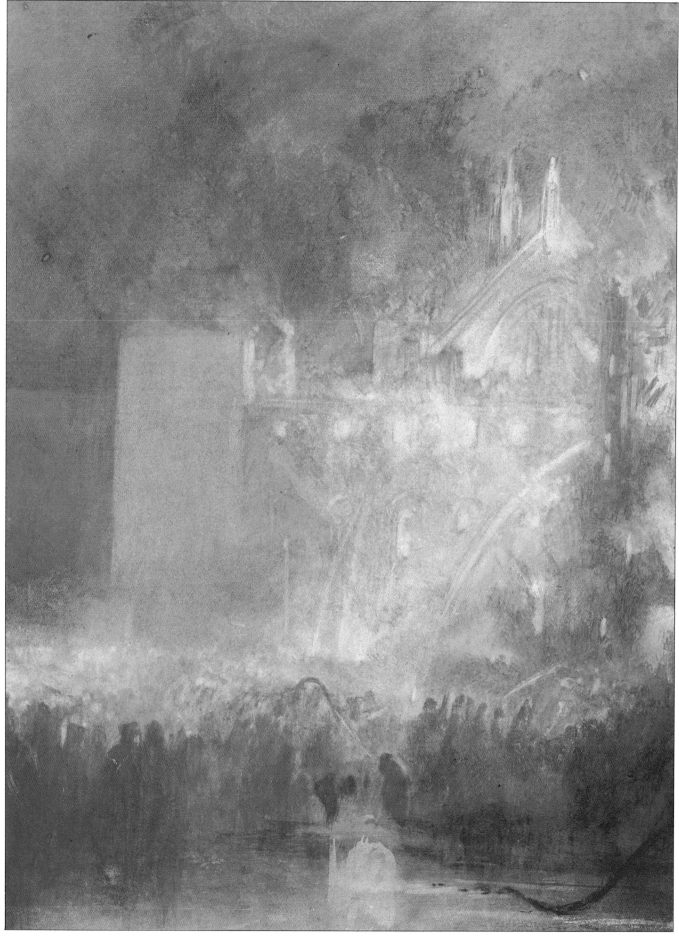

3 *Actual size detail*

NORHAM CASTLE, SUNRISE

c1835-40

35³/₄×48in/78×122cm

Oil on canvas

Clore Gallery for the Turner Collection, London

A scene such as this — a castle set against the skyline overlooking a meandering river and surrounded by rolling hills — was the epitome of the picturesque landscape which Turner sought when he had first discovered Norham Castle in 1797. The effect was completed by the sun rising behind the castle, emphasizing the dark romantic silhouette of the crenellated walls and illuminating the river below the reflected light. This was the theme of his watercolor, *Norham Castle on the Tweed, Summer's Morn*, which was shown at the Academy the following year. As one of his most successful compositions, he included it in his *Liber Studiorum*, a book of engravings produced from 1807-1819 in imitation of Claude's collection, *Liber Veritatis*. (This, like Turner's, was intended as a set of authenticated works produced as a safeguard against unauthorized reproduction.) From the *Liber Studiorum*, the subject was reworked as an illustration for the collection *Rivers of England* of 1824.

Turner's interest in Norham was developed by a further visit in 1833. Unexhibited and officially unfinished, this late version of the subject has clearly moved far from the conventions of the picturesque. Norham is unique in Turner's work as being a specific scene that recurs almost through his entire career, and his many treatments of it evidence the satisfaction it afforded him. As his work progressed, the fundamental components of the scene were stripped, as here, of all distracting detail, a tendency which occurred more and more. The theme of the single outcrop above water is repeated in watercolors of the peaks of Rigi and Pilatus above the Swiss lakes, or in the château of Amboise above the Loire in France, and in each case it seems to provide a central focus in a world of air and water, like a ship glimpsed through the mist.

As details are reduced to suggestions, so Turner has narrowed the range of colors to concentrate on variations of blue, yellow and red. These are laid onto a white ground, a departure from the academic tradition that Turner had learned in his youth from Reynolds. This made use of the ocher ground first developed by the great Venetian masters, which gave a warmth and an underlying deep tonality to the finished work. Ironically, Turner's own visits to Venice had hastened his rejection of this practice, and he had developed the use of white grounds to heighten the tonality of his work. The method enabled him to recapture in oils something of the translucence of watercolor by allowing the white ground to shine through the thin glazes of color just as in watercolors the paper reflects back through the wash. Once again, we see how Turner's expertise in the two media provides him with a greater flexibility of technique in both.

Here the white ground assumes the nature of the pure light from which Turner has extracted color, following the practice of obtaining colors from natural light via a prism, with which he was very familiar. The brilliance of the picture is achieved through this prismatic use of color, juxtaposing almost pure primary colors set against carefully controlled secondary harmonies. The effect of an all-enveloping light which creates for our eyes the features of the landscape is a technically complex parallel to the simple freshness of the sunrise which the picture shows us.

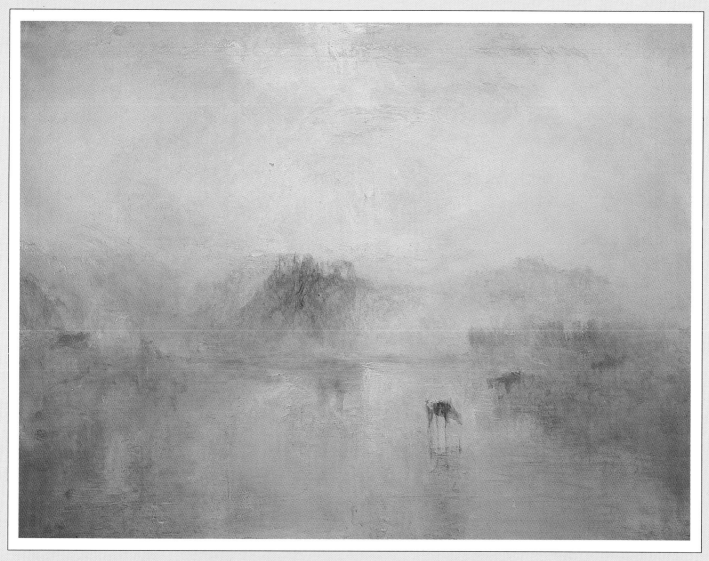

This final, unfinished version of the subject that Turner painted many times is taken from the same viewpoint as his first, dramatizing the scale of the castle and distant hills, but there the similarity ends. Only the castle itself and the foreground cow, necessary to suggest scale, are retained. In the lower part of the canvas the areas of pure color from which it is composed converge on the central motif like spokes around the hub of a wheel, suggesting the spectrum and the color theories that so fascinated Turner. In the upper half, a series of semi-transparent applications builds up a smooth, creamy surface over which the glow of the sunrise radiates.

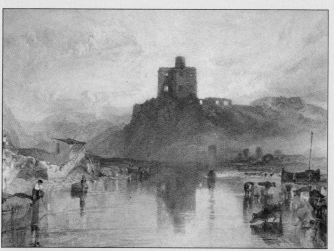

Norham Castle on the River Tweed, Summer's Morn
1897

This watercolor, shown at the Academy in 1898, was Turner's first painting of the scene, and was engraved for inclusion in his *Liber Studorium*, and later reworked for the collection *Rivers of England.* It includes all the anecdotal details appropriate to a "picturesque" illustration, all of which were stripped away in the later painting, where his interest lay in the essential combination of sunrise, water and hills.

1 The crest of a line of hills is just suggested by thick strokes of pale yellow, applied with a fine brush but with enough vigor and pressure to push the paint out to form tiny lines and ridges of impasto. This was an effect that Turner often created by using the sharp handle of the brush. Beyond this, in the horizon caught in the light of sunrise, form is all but transparent, with only the faintest pale yellow glaze differentiating the hill from the sky.

2 The extreme fluidity of Turner's application is clearly revealed in the lines of blue allowed to run down to create small gullies of color forming the shadows beneath the walls. More regular touches suggest towers and battlements against the sky, and Turner has pressed the brush sideways to leave a horizontal imprint, a hint of regularity in the general insubstantiality.

3 *Actual size detail* The foreground cow is reduced to a pale, semi-abstract umber stain with a dab of off-white impasto over the haunch and touches of brown over this, at the belly and shoulder. A thin brush has been wiped dry over the canvas in a few vertical and horizontal strokes to suggest the reflection of legs and body. A transparent, matte chalky layer lies over the blue underpainting beyond the head, while below its outstretched neck a fluid area of pale yellow is brushed down to end in an impasto bar of reflection.

3 *Actual size detail*

THE DOGANA, SAN GIORGIO

1842

24½×36½in/62.25×92.75cm

Clore Gallery for the Turner Collection, London

"Venice was surely built to be painted by the Canaletti and Turner" wrote a critic in 1842, and it was through Canaletto that Turner first approached the city in his first exhibited Venetian oil of 1833. This included the figure of the eighteenth-century Venetian at work painting the city, just as Turner's first major oil dealing with his trip to Rome had shown Raphael, surrounded by his paintings, set against a panorama of the city. For the first public treatment of the theme Turner had once again introduced his own work under the screen of art history, but his private response to Venice had been less reticent. On his first visit in 1819 he had produced mostly drawings, but on subsequent occasions, in 1833 and 1840, his impressions of Venice were recorded in a series of vivid and highly personal watercolors.

Turner had long been familiar with the tradition of Venetian painting, whose greatest Renaissance figures had anticipated his own obsession with light and color. When in the Louvre it had been Titian who had created the deepest impact upon him, with his sense of violent drama carried on from the foreground figures into the landscape and heightened by emotive color. Veronese's subtle color harmonies had also impressed him and, in Venice itself, the powerful, dramatic lighting of Tintoretto. But it was the city itself and its unique setting, the inspiration for all these painters, to which Turner responded most deeply. First articulated in the watercolors painted while in Venice, his response to the city was deeply pondered before he began to transfer his sensations to the more formal and considered medium of oil paint. In this respect his Venetian scenes echoed his response to Italy as a whole, but in a more specific sense the regularity with which he painted such views from 1833 to 1846 reflects a need satisfied at this stage in his development by Venice alone. The canals and lagoons amplified Italy's bright, diffuse light, the coastal setting provided the ever-changing light effects associated with the conjunction of air and water, and the entire fabric of the city constituted a magical and picturesque stage on which this play of light was enacted. As the critic suggested, it was an ideal subject for Turner during the period of the 1830s and '40s when his canvases, losing the traditional chiaroscuro of his earlier work, were growing brighter and more insubstantial, just as the marble facades of his beloved Venice were dissolved in brilliant white light.

The white ground that Turner introduced with his Venetian views was of profound importance to his development, giving his colors a background of purity and brilliance and helping to banish muddy tones. Although by this stage he was well on the path to the insubstantiality of his later works, we see here a certain tension between solidity and diffuse light. The gondolas at center and left, dark and solid, are devices to suggest depth and help direct the eye across the shimmering veil of sea and sky. The delicate layers of paint that he has used to build up the surface are his chief concern, rather than the conventions of structure, which he was later to discard.

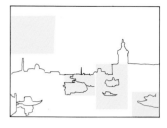

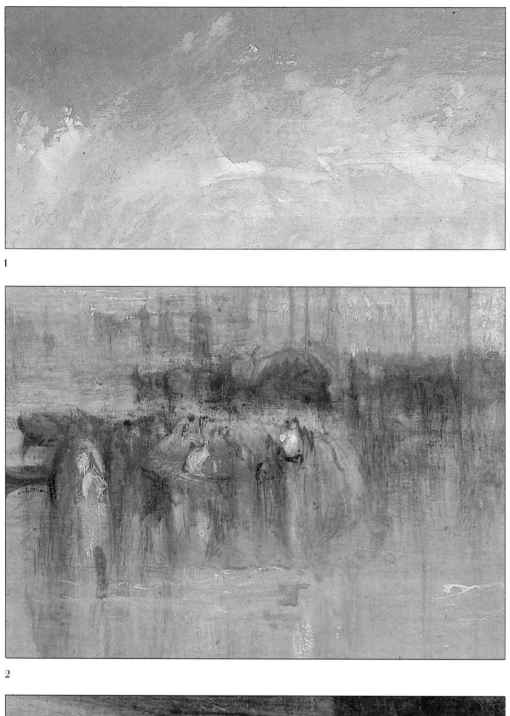

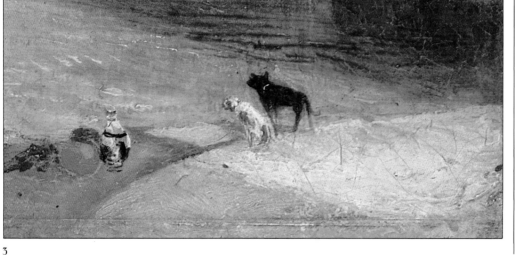

1 Above the pale ground, Turner has built up a steadily deepening blue to balance the tones at the bottom right of the painting. The white clouds have been laid over this solid texture, thickly applied with the palette knife, with the paint pulled out to leave diminishing dry smudges at the edges.

2 The form of a heavily laden boat has been created by the use of an umber glaze, with a drip left beneath the boat to suggest the reflection. Over this area Turner has used a very fine brush to trace delicate lines down toward the water from the white shirts of the boatmen, while beneath the boat single lines of pale yellow and white form the bars of reflection, solid touches of impasto on the smooth glazes.

3 Blue, white and gold, the key colors of the painting, are neatly summarized in their purest form in the two foreground pots. The two dogs, a favorite detail in Renaissance Venetian painting, serve to denote the extremes of tonality on which the picture hangs.

4 *Actual size detail* The details of the façade of the Salute Church are created by evenly applied white over pale amber, dabbed and sponged to make an almost pitted surface that from a distance suggests a dazzling iridescence. The foreground gondola serves to plot the central recession by the contrast of low tones against the pale background.

4 *Actual size detail*

PEACE: BURIAL AT SEA

1842

34¼×34⅛in/86.9×86.6cm

Oil on canvas

Clore Gallery for the Turner Collection, London

Shown in the same Academy exhibition as *The Dogana, San Giorgio* (see page 51), this was one of a pair with *War, The Exile and the Rock Limpet*, a painting of Napoleon on St Helena. The latter was of the same dimensions as this work, and was a sunset scene painted in livid reds and yellows. The contrast with the cool blues of *Peace* was intentional, and illustrates Turner's conscious use of the emotional value of color. In the Napoleon picture, blood red was clearly a reference to the sanguine memories of the exiled soldier, while the blue used here creates a more elegiac mood. This contrast tallies with the theory of color developed by Goethe, whose book on the subject Turner had studied when it was translated into English the previous year. This proposed a division of colors into positive and negative groups, each associated with a range of appropriate emotions, which are echoed in the titles Turner used for these works. He accompanied both with lines from his fragmentary poem *The Fallacies of Hope*. The lines for this painting were:

The midnight torch gleamed o'er the steamer's side

And Merit's corpse was yielded to the tide

The midnight scene Turner has imagined was the burial at sea (off Gibraltar) of the painter David Wilkie, who died returning from Palestine. Wilkie had been the most successful painter of his generation, and his popular subject-matter of rural interior scenes had once been imitated by Turner in his vein of competitive tribute. This work was produced in something of the same spirit to complement another painterly homage by a friend, who chose to depict the burial from the ship's deck. The unremitting black of the ship's sails, for which even his champion Ruskin criticized Turner, has been seen as a further tribute to Wilkie, who was noted for the use of black in his later pictures. Turner's famous reply to criticism of the sails, that he wished he could have made them "even blacker," was a typically combative response to the harsh criticism both *War* and *Peace* received compared to the praise for the more seductive Venetian pictures.

This is one of Turner's most direct meditations on death, which Ruskin saw as being the ultimate concern of his art. Now aged 67, Turner had suffered the death of many of his friends and patrons, as well as his own father to whom he was so close and who had helped to manage his business affairs throughout his life. Contemporaries noted how solicitous Turner was during illnesses, and how keenly he felt a death. From the mood of peaceful acceptance and reverie of the *Evening Star* (see page 35) the tone here has become heavier and more tragic, perhaps because it celebrates an untimely end. Linked with the declining Napoleon, Wilkie's death is treated in a heroic vein, and Turner dramatizes by using the elements to emphasize the tragedy.

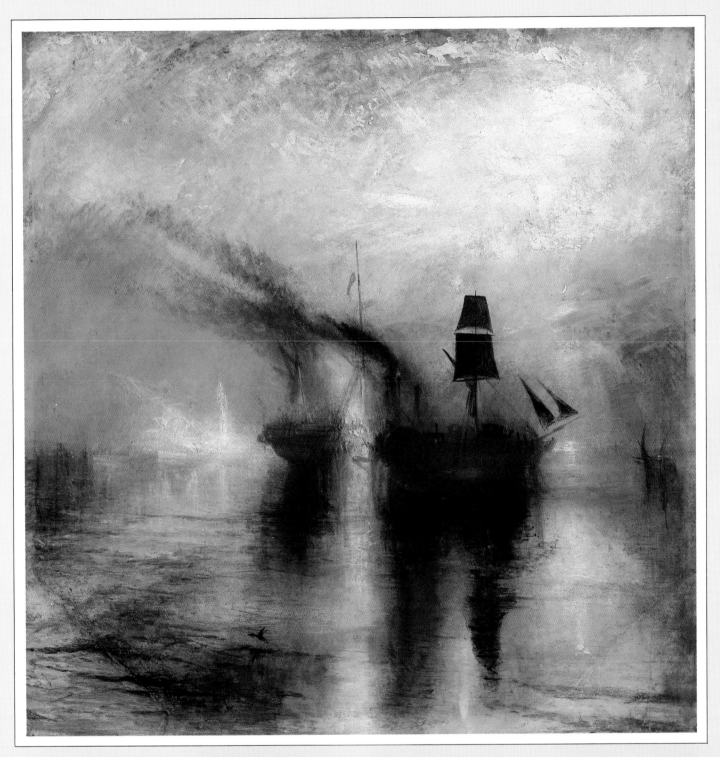

Turner planned this painting and its companion piece, *War*, as octagonal compositions, as can be seen from the painting of the bottom corners. The present frame reveals the glazing and overpainting intended for the finished work, sharply contrasted against the areas that remain undeveloped. The arrangement of the linear composition confirms the painter's intention, with the diagonals of smoke and the Rock of Gibraltar behind echoing what were to have been the original corners. Turner began to favor square and octagonal formats as he concentrated increasingly on a central motif, in particular the central vortex of light that became the main theme in many of his late works.

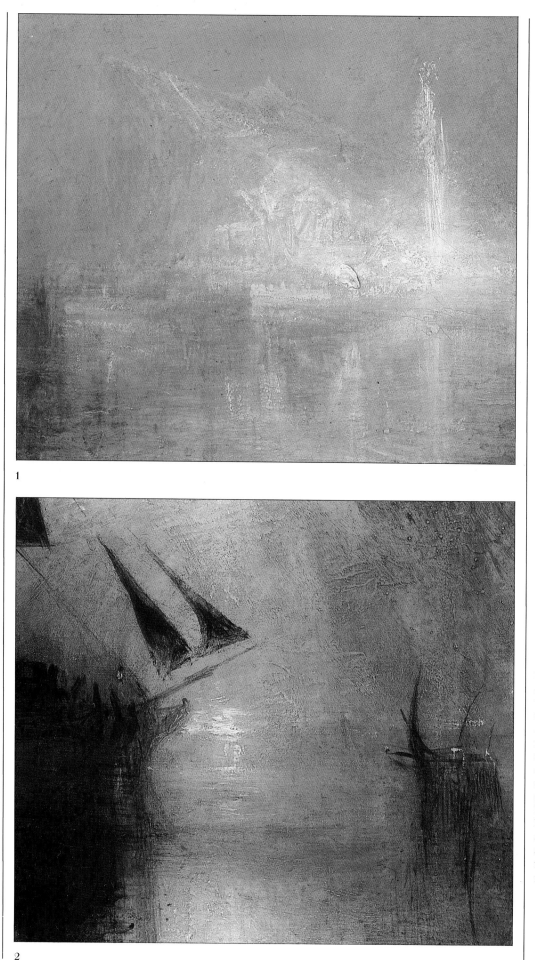

1

2

1 A soft gray has been smoothed over the blue underpainting to the right of the rock and on the cliff face itself, where long, elliptical strokes describe the curvature of the structure. Ocher has been used for both this and its reflection. The rock itself is firmly outlined, and on its lower slopes, strokes of white are applied over the moist underpainting and then scored with brush handle or fingernails. This has increased the surface movement, and the gray background beyond has also been given additional surface interest by light sponging.

2 The dark sails and rigging have been faintly outlined in dry paint, and black has then been used to fill out the shapes. A few moist touches of white suggest moonlight on the horizon and help to fix a sense of distance, pushing the boat toward the viewer.

3 *Actual size detail* Turner places the torchlit ceremony at the very center of the composition, a position of formal solemnity. The deep gash of light cutting through the somber silhouette of the ship is one of his most original and dramatic inventions. It is formed by a thin gold glaze over which the heavy shadow of the ship is drawn at each side like a curtain, giving faint glimpses of the painting beneath before the blackness becomes total. The highlights, applied with thick impasto, are echoed in the reflection in the water far below — a few rapid touches of the brush.

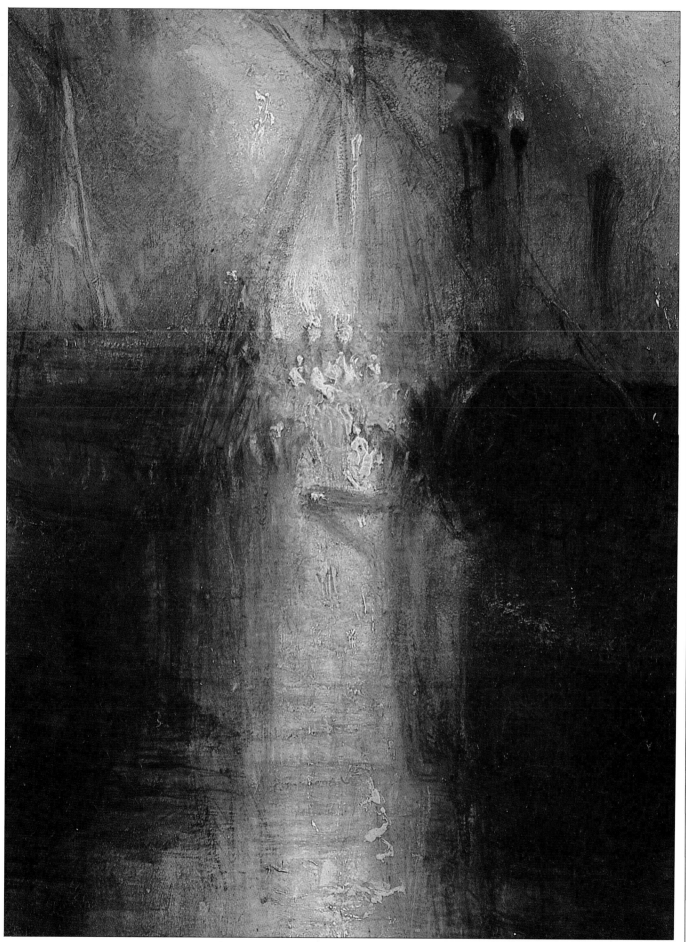

3 *Actual size detail*

RAIN, STEAM AND SPEED

1844

35¾×48in/90.8×121.9cm

Oil on canvas

National Gallery, London

Two visitors to the Academy exhibition of 1844 were surprised to be interrupted in their discussion of the implausibility of this work by a lady who firmly proposed the authenticity of a scene she had witnessed herself. She later explained to Ruskin that she remembered an elderly gentleman peering out of the carriage window of the Exeter express for a full nine minutes to observe the rain. On seeing the painting she immediately recognized the scene and knew her companion had been Turner. The artist was surprised more than once at a moment of creative genesis, surprisingly so considering the lengths to which he occasionally resorted to cover his tracks. The most notable of such occasions was when he was observed busily making sketches by a fellow painter traveling on the same Thames ferry before which the decrepit Trafalgar battleship the *Téméraire* happened to have been towed on its journey to the breakers' yard. The story of the Exeter express can also be compared to the reminiscence of the son of a patron who watched a storm over the Yorkshire Dales with Turner, recognizing it much later transformed into *Hannibal Crossing the Alps* (see page 12).

Although Turner had a remarkable capacity for recalling unaided the details of landscape and weather glimpsed possibly years before, it is hard to see this picture purely as a visual memento. Yet in this respect it has often been compared to Claude Monet's Impressionist railway scenes of some thirty years later, which shared both the modernity of subject matter and a similar looseness of handling. Monet certainly knew Turner's work from his visits to London, and it is to the Impressionists that one turns to seek Turner's influence on the art of his century. Yet Monet's own comment on Turner, that he felt distanced by "the exuberant romanticism of his fantasy," pinpoints the fundamental difference in outlook between the two. Monet's point of view was that of the uninvolved observer, while Turner sought to express a more personal involvement with his subject. Today we can appreciate Turner's late manner in the context of abstract art, and can enjoy the exhilarating variety of his touch, regardless of content, but to Turner himself the content was of great importance. Such touches as the attention to detail in the hare running before the engine — perhaps seen as "speed" by Turner — remind us that this is still a very nineteenth-century work, perhaps even more so because of the visionary treatment of the theme.

The setting is the railway bridge at Maidenhead over Turner's beloved Thames. The high viewpoint shows a wide sky and a broad expanse of water over which the steam engine rides. Like a Venetian view, the strip of land separating the two has become a glorious blur of light, the outlines dissolved by rain and cloud. Against this background the strongly recessed diagonal of the bridge brings the train dramatically forward, the sharply focused form of its funnel already suggesting its arrival in the foreground. The historical importance of this depiction of early rail travel obscures Turner's reaction to the revolution in transport. Ruskin viewed the railway with outright hostility, but Turner's treatment appears ambiguous. His excitement at the concept of speed is evident, but there is also a hint of dread in the black engine, its glowing fire and the tiny figures behind hurtling through the rain.

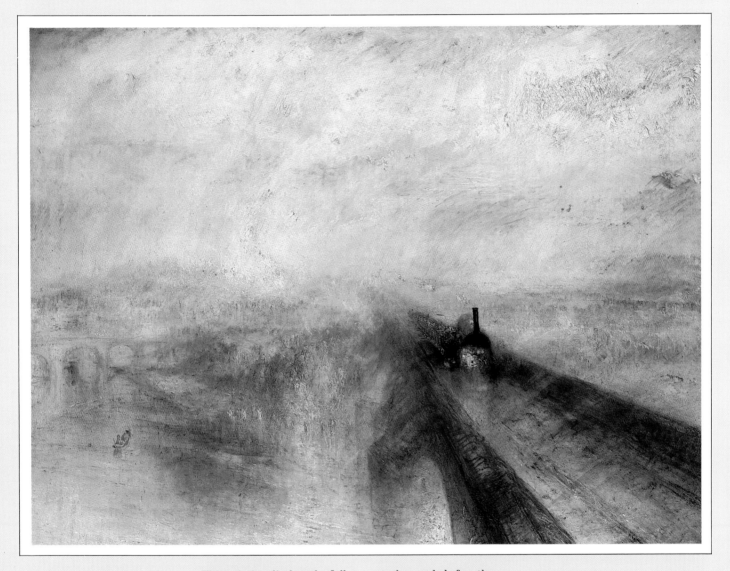

This painting displays the full technical range of the late Turner. Over the characteristic white ground of this period, the general tonal areas of the composition have been mapped out in underpainting, with further touches added while this was still moist. As the painting developed, so Turner's touch grew more impetuous, with short, rapid strokes made before the application of the heavier white impasto, much of which has been scraped away. Not only did Turner use both ends of the brush and various cloths, but he was also known to have applied paint with his fingers in his late works. Yet despite the broad handling, a considerable range of detail is suggested.

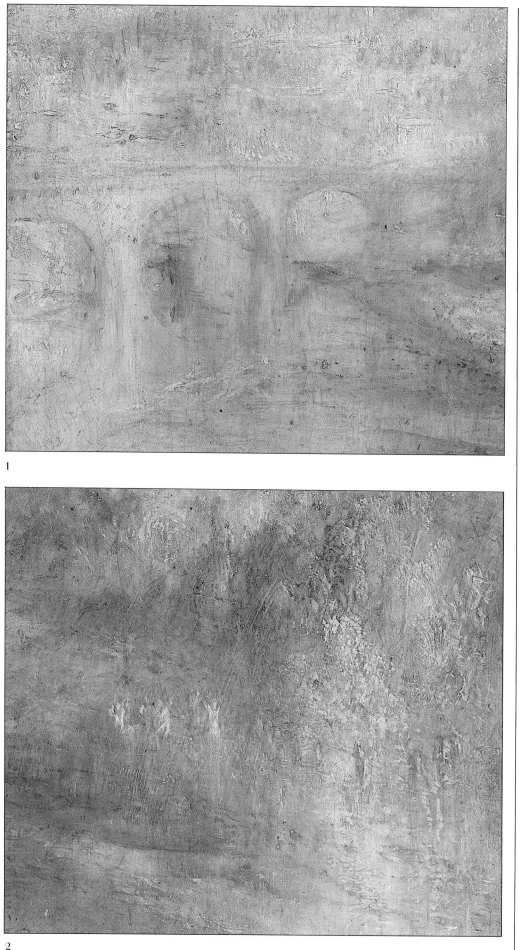

1

2

1 Around the periphery of the painting Turner has allowed more of the ground to show, and the brushstrokes remain separate, leaving airy space between them. A soft, loose and fluid underpainting of rose and lilac is used across the bridge, particularly to the right, where a very thin layer gives a hazy pink glow where bridge and shore join. Later, thicker, touches are the white and gold highlights, the latter used in short dabs above the bridge to suggest distant foliage.

2 Over a formless blur of pale amber, a fine brush has been used to scumble the foliage of the autumnal trees. A barely tinted chalky-white glaze is pulled across with long strokes from the bridge to create the effect of a fine veil of rain falling over the river. Long, curving strokes have been used to the left of the trees, passing over the tiny touches of white suggesting figures on the bank below.

3 *Actual size detail* The funnel offers the area of the greatest clarity and most opaque painting. From it, palette-knife smears of white form wisps of steam over a ground so thinly covered that the fine weave of the canvas is visible in places. A touch of gray has been smudged by hand or cloth for the smoke of the boiler diffused in the damp air, contrasting with the bold knife-smear of white across the front of the engine. This, with the scarlet used around it, is the area of strongest color contrast, giving greater clarity to the central motif.

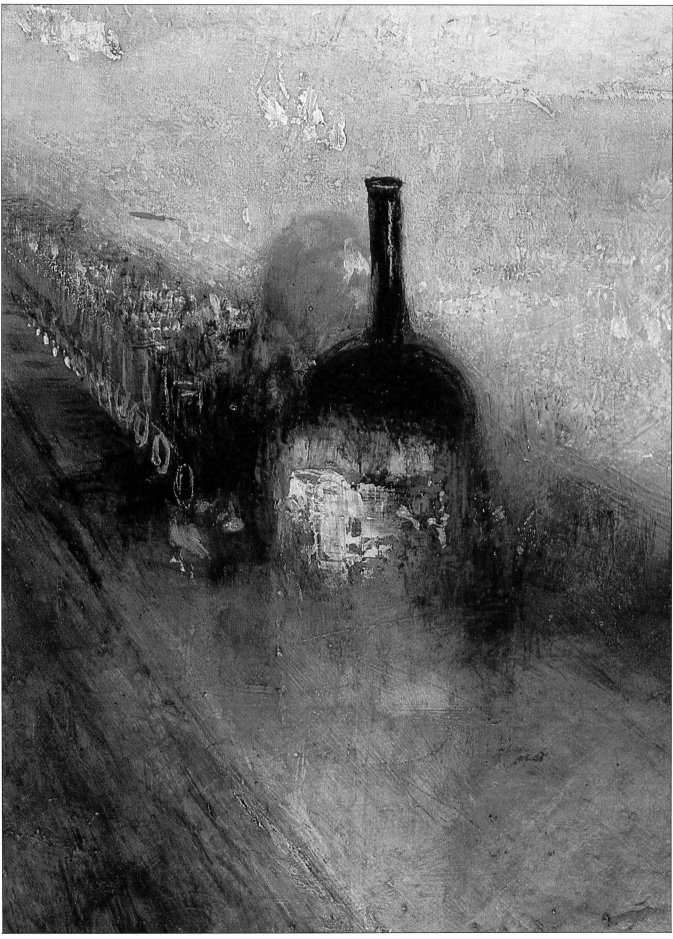

3 Actual size detail

INDEX

PHOTOGRAPHIC CREDITS
Ashmolean Museum, Oxford 15 bottom; Birmingham City Art Gallery 9; Clore Gallery for the Turner Collection 6, 12, 14, 15 top, 19-21, 23-25, 27-29, National Gallery, London 10, 11 top, 31-33, 35-37, 59-61; National Museum of Wales, Cardiff, 8; Service photographique de la Réunion des musées nationaux, Paris 11, 39-41, 43-45, 47-49, 51-53, 55-57; University of Reading, Ruskin Collection, 7